Museums of the World

Kunsthistorisches Museum, Vienna

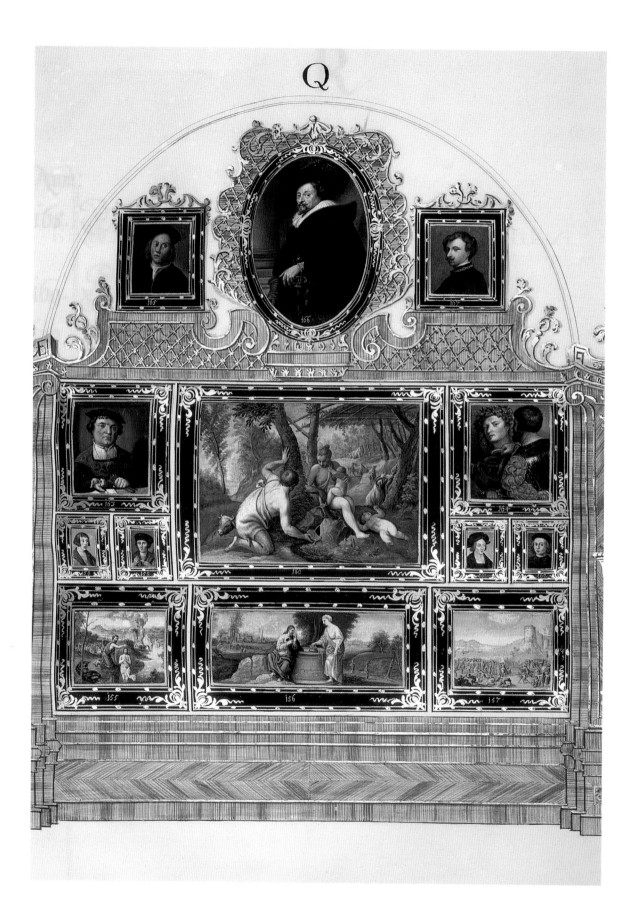

Kunsthistorisches Museum, Vienna

The Paintings

by Wolfgang Prohaska

C.H. Beck/Scala Books

FRONTISPIECE **Ferdinand Storffer**
Neufelden/Upper Austria 1693 - Vienna 1771
Bildinventar der Sammlungen Kaiser Karls VI.
in der Stallburg in Wien (Painted inventory of
Emperor Charles VI's collections in the Stallburg
in Vienna), vol. I, 1720 (Inv. no. Min 75)
The pictures illustrated include Rubens's *Self-portrait*,
with *Adam and Eve after their expulsion from Paradise* by
Veronese below it, and – with its proportions very much
altered – Annibale Carracci's *Christ and the Samaritan*
woman at the well, with Patinier's *Baptism of Christ* to its
left and to the right above in the middle Titian's *The bravo*.

FRONT COVER **Diego Velazquez**
Infanta Margarita Teresa in a pink dress, c.1653/4

BACK COVER **Pieter Bruegel the Elder**
Peasant dance, c.1568

©1997 Philip Wilson Publishers Limited, London

First published in 1997 by Scala Books
an imprint of Philip Wilson Publishers Limited
143-149 Great Portland Street
London W1N 5FB

ISBN 3 406 42176 8

Translated from German by Judith Hayward
Photography Kunsthistorisches Museum, Vienna
Layout by Sara Robin
English translation edited by Jenny Marsh
Printed and bound in Italy
by Sfera International, Milan

The dimensions of all paintings and works
of art are given in centimetres, unless stated
otherwise, and presented as height x width

Contents

History of the Paintings Collection

The Paintings Collection of the Kunsthistorisches Museum owes its existence and its special characteristics to a number of great collectors belonging to the House of Habsburg. It therefore still has something of the nature of an excellent royal private collection, with all the advantages and drawbacks that entails, in spite of today's radically altered political circumstances and the many acquisitions made in the nineteenth and twentieth centuries.

It originated in the sixteenth and seventeenth centuries, and its essential internal and external features had already been mapped out by 1800. For all its variety and richness, it is unsystematic in comparison with national galleries such as those in London and Berlin (not to mention American collections) which were established later from an encyclopedic or art-historical point of view. The collection is not a textbook to the history of art, presenting every period, country and style in an even-handed way and aiming to be historically comprehensive. Rather it has strengths, which are certainly not comparable to those of any other collection of paintings, and at the same time quite substantial gaps; by and large these have been consciously or unconsciously respected by its curators from one generation to the next.

The unparalleled richness of sixteenth-century Venetian and seventeenth-century Flemish painting, the comprehensive representation of Italian Baroque painting which can hardly be matched anywhere else, the twelve authenticated Bruegels – out of a total surviving œuvre of about forty paintings – and the wonderful collection of Early Netherlandish and Early German paintings are counterbalanced by an almost total lack of French and English artists and of Italian 'Primitives', painters working in Italy in the thirteenth and fourteenth centuries and the early Renaissance. The collections of seventeenth-century Dutch and eighteenth-century Italian art are surprisingly small for a gallery of this standing, even if there are outstanding works from these schools and periods.

If we were to start the actual history of the Habsburg Paintings Collection with Emperor Maximilian I (1459-1519), we would find little more than a point of departure for the Habsburgs' activities as collectors of pictures. The only painting in imperial ownership which may have been painted at his behest, Dürer's portrait of Emperor Maximilian I cannot be proved to have been in the collection until later. Maximilian must certainly have owned pictures. For him and his direct descendants, and indeed for the start of any and every royal collection of paintings, the portrait was of course primarily a vehicle for family political alliances or even more for

David Teniers the Younger
Antwerp 1610 - Brussels 1690
Archduke Leopold Wilhelm in his gallery in Brussels (detail of page 79), *c.*1651
Canvas, 123 x 163 cm
(Inv. no. 739)
Commissioned by Archduke Leopold Wilhelm; then in the possession of his brother, Emperor Ferdinand III, in Prague

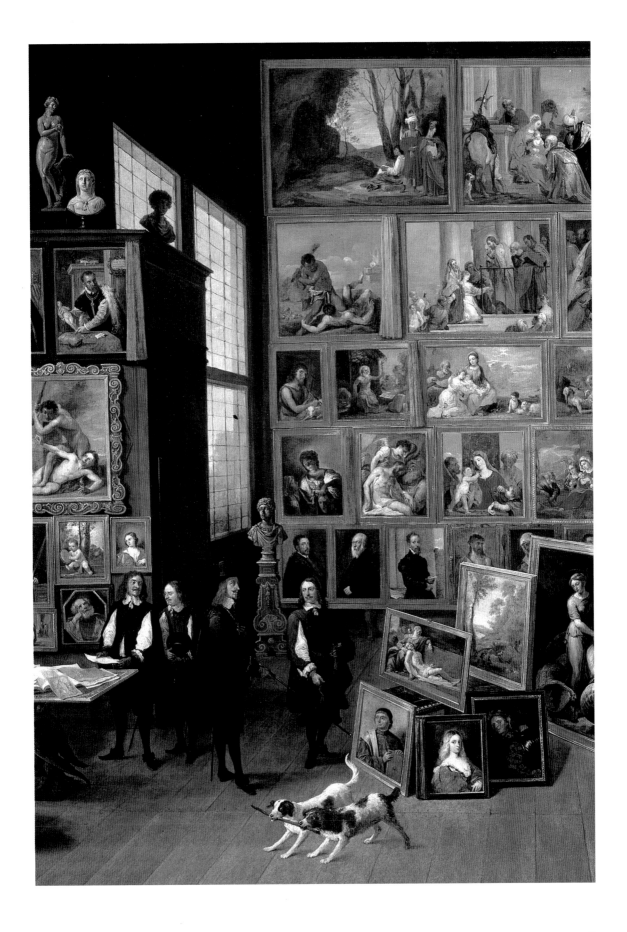

genealogical interests; like many of his peers, Maximilian was especially fond of pursuing these. However the greatest artistic expression of these interests was to be found in Maximilian's monumental tomb in Innsbruck, cast in bronze, rather than in painting.

This interest in the portrait, in people of family, political or military significance, distinguished by physical beauty or great character, was also a dominant characteristic of one of the most interesting Habsburg collectors, Archduke Ferdinand II of the Tirol (1529-95), the son of Emperor Ferdinand I, who was first appointed Regent of Bohemia, then Governor of the Tirol. As well as the famous 'Kunst- und Wunder-, dessgleichen Rüst- und Harnisch-Camern' (Cabinets of Art and Curiosities and Armoury – as they were described in his will dated 1594) he amassed a collection of over 1000 miniature portraits for Castle Ambras close to Innsbruck, now exhibited in the Numismatics Department of the Kunsthistorisches Museum.

This emphasis on portraiture, to some extent a feature of every royal collection, is particularly noticeable among the Habsburgs, with their strong sense of family, right from the outset, so that we can legitimately talk of a certain 'preponderance of heads' in the Vienna Paintings Collections – even today, after a collection of historical portraits of the Habsburgs and the related ruling houses associated with them was set up at Schloss Ambras in 1976 from the stock of the Paintings Collection.

With Emperor Rudolf II (1552-1612) we come to the most all-embracing collector in the Habsburg family. He grew up in Spain at the court of his uncle, Philip II, and was influenced artistically by the collections of the Spanish Habsburgs. He was a highly cultivated, introverted man subject to fits of depression and even delusions; his decidedly psychopathic tendencies were reinforced by a powerful sexual appetite. As a ruler he took up residence in Prague where he created an exceptionally varied Kunstkammer, encyclopedic in its range, which was shrouded in legend even in his own lifetime. With him the collecting of art emerged from the realm of documenting family politics, albeit on a universal scale, or that of the 'curiosity', and took its place on equal terms with the study of science, with art standing alongside the sciences in a carefully thought-out, richly interconnected world order. Furthermore Rudolf instigated his purchases with a subtle feeling for quality and was also primarily motivated by criteria intrinsic to art.

Rudolf was a passionate collector who pursued his objectives with extreme tenacity: 'als, was der Kaiser wais, meint er, er mies' haben' (what the Emperor knows of, he thinks he has to have), as Archduchess Maria of Inner Austria put it. As the daughter, sister and aunt of Albrecht V, Wilhelm V and Maximilian I of Bavaria, themselves great patrons of the arts and collectors, she knew what she was talking about. The idea that all the artistic possessions of the Habsburgs should come under one person, i.e. the emperor, first emerged with Rudolf, though it was not implemented consistently. After the death of his uncle, Archduke Ferdinand II of the Tirol, Rudolf bought the Kunstkammer at Schloss Ambras from his heirs, and most of the estate of his brother Ernst who was Governor of the Netherlands (1593-95) also came into his possession.

Even though most of Rudolf's extensive collection of paintings in Prague was scattered to the four winds, especially as a result of Swedish looting in 1648, considerable sections of it went to Vienna shortly after the emperor's death and consequently remained in Habsburg possession.

As far as cautious inferences regarding something resembling a preference in taste may be drawn from reconstructing his picture collection, what Rudolf prized

may provide a clue to the essential characteristics of this so contradictory ruler. There is the high intellectual ambition manifested in those works in which the act of creating form, artistic and programmatic invention and the process of inventing are expressed to the point of being contrived. Thus Rudolf was a passionate, obdurate, sometimes downright unscrupulous collector of the works of Dürer. The art of Rudolf's court painters in Prague, of Bartholomäus Spranger, Hans von Aachen or Joseph Heintz, equally experimental at a different level, points in the same direction, and today forms one of the characteristic groupings in the Vienna gallery. On the other hand, Rudolf's efforts to obtain his brother Ernst's collection containing the works of Bruegel, the greatest depictor of the world as it is or as it could be, may perhaps bear witness to the vain efforts of the recluse in Hradčany Castle in Prague to come to grips with reality.

Rudolf's fondness for sensual subjects was obviously general knowledge; clever attempts were made to take account of it in gifts to the emperor. Thus the list of pictures from his estate which went to Archduke Albrecht in Brussels reads like a proposal for compiling a cabinet of erotica, and of course Rudolf's court painters mentioned above satisfied the emperor's requirements in this respect in a particularly ingenious way. However the protracted negotiations in Spain to buy Correggio's *Loves of Jupiter* are proof that Rudolf demanded first-rate artistic quality in this field too. Although only fragments of Rudolf's picture collection are still in Vienna, his collection must nonetheless have been regarded as a heritage which created obligations and an ideal point of departure for all later patronage of the arts by the Habsburgs.

The true father of the Paintings Collection as it still stands today was Archduke Leopold Wilhelm (1614-62), the brother of Emperor Ferdinand III. Leopold Wilhelm had taken holy orders and already had a more or less successful ecclesiastical and military career behind him when he started collecting in grand style. His purchases of pictures, made almost entirely while he was Governor of the Netherlands on behalf of the King of Spain (1647-56) and favoured by political events at the end of the Thirty Years' War and the downfall of the British monarchy in 1648, had two aims. He built up a collection of his own, which he transferred to Vienna in 1656 when his political role in Brussels came to an end, exhibiting it at the Stallburg, part of the Hofburg. He had these works catalogued in 1659 in an extremely precise inventory, still regarded as exemplary today, finally bequeathing them in his will to his nephew, Emperor Leopold I. These 1400 or so pictures – the Italian component in particular was recorded in the Archduke's lifetime in an engraved picture inventory, the *Theatrum Pictorium*, and in the so-called 'Painted Galleries' by his court painter David Teniers, so becoming widely known – are the basis of the current Vienna Paintings Collection. At the same time Leopold Wilhelm bought pictures for the collection of his brother, the emperor, to fill the empty rooms of his plundered castle in Prague. Some of these were transferred to Vienna in the reign of Emperor Charles VI, as well as at a later date.

Leopold Wilhelm's interest was concentrated primarily on Flemish and Italian – especially Venetian and Upper Italian – painting of the fifteenth and sixteenth centuries. It was a benefit in this respect that after the execution of the British king, the great collector – Charles I – who was obsessed with painting, and the confiscation of his collection and the collections of his courtiers, large quantities of Venetian paintings in particular were sold in the Netherlands. Leopold Wilhelm promptly snapped them up.

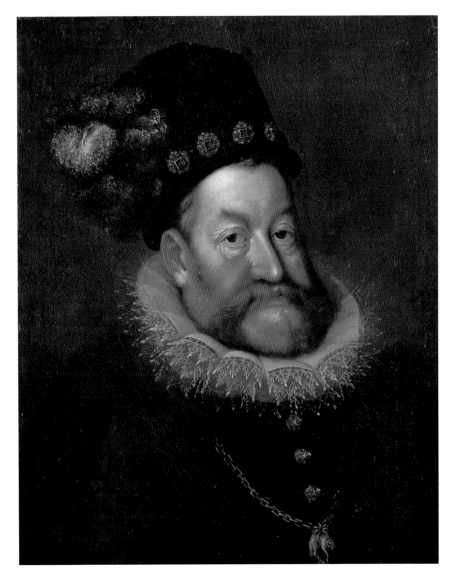

Hans von Aachen
Cologne 1551/2 -
Prague 1615
*Emperor Rudolf II, c.*1606/8
Canvas, 60 x 48 cm
(Inv. no. 6438)
Probably from Rudolf II's
Kunstkammer

Emperor Rudolf II (1552-
1612), the son of Emperor
Maximilian II, grew up in
Spain and became emperor
in 1576; he was one of the
most important Habsburg
art collectors and patrons
of the arts. Considerable
sections of his collection
have been preserved in the
Kunsthistorisches Museum
in Vienna, while others
were scattered throughout
the world as a result of the
conquest of Prague by the
Swedes in 1648.

His purchases ranged from Giorgione by way of Palma il Vecchio to Titian,
Veronese, Tintoretto and the Bassano family, from Antonello da Messina by way
of Bellini to the great masters of Bergamo and Brescia. The Flemish painters went
from van Eyck, described in the inventory – the interest in history can already be
discerned – as the inventor of oil painting, by way of Goes, Geertgen, Gossaert,
the Massys family, Patinier and Aertsen to Jan Bruegel. At the same time Leopold
Wilhelm collected the works of his Flemish contemporaries: David Teniers was his
court painter, and while Peter Paul Rubens himself had died shortly before the start
of his governorship the whole circle centred on Rubens was represented with rare
completeness in his collection, and consequently in the gallery in Vienna. Leopold
Wilhelm's preference for items with small figures, perfectly elaborated in painterly
terms, for peaceful classic painting tending to provide close-up views, for the
connoisseur's picture, the still-life in the broadest sense, is plain to see: hence his
love for minutely detailed Early Netherlandish painting, for Giorgione and Lorenzo
Lotto. That is why he owned Rubens's 'Small Lamentation', the *Stormy landscape*,
but none of the large-format allegories, hunting scenes or mythological paintings.

For the same reason among the seventeenth-century Italians he liked Fetti, Strozzi, Forabosco and Guido Cagnacci (he brought him to Vienna) but was less fond of 'rhetorical' painters such as Pietro da Cortona, Domenichino or Guido Reni. His purchases on behalf of his brother the emperor for the great flights of rooms at the Prague castle were more in keeping with 'Baroque' taste, with decoration that dominated the space and with lively, large-format compositions to the fore.

While the interests of Emperor Leopold I (1640-1705) were in fact directed less towards painting than towards music, theatre and – willy-nilly in those turbulent times – the wars against the Turks and the French, it was nonetheless during his reign that the various portraits of the infantes and infantas by Velazquez were sent to Vienna from Madrid for personal and dynastic reasons, as well as the art works belonging to the Tirolean line of the Habsburgs first acquired before being displayed in Innsbruck when that branch of the family died out in 1665. As a result of marriage in two generations with princesses from the Medici family the Tirolean Habsburgs had enjoyed close connections with Florence. Thus the Vienna gallery not only now has a fine collection of Florentine Baroque painting but also for example came to possess one of the greatest masterpieces in the museum, Raphael's *Madonna in the meadow*.

The collections scattered through the various official residences or left in them were virtually crying out to be arranged systematically in a Baroque sense. But it was not until Austria had fended off the double military threat from east and west, from the Ottoman Empire and France, and after the War of the Spanish Succession, i.e. at the height of the Austrian 'heroic age', that Emperor Charles VI (1685-1740) undertook the task of bringing most of the paintings owned by the Habsburgs together under one roof, exhibiting them afresh in the rooms of the Stallburg in Vienna which had been specially adapted for the purpose by artists. Completely in accordance with the spirit of the age, a decorative system of openings in the carved and gilded wall panelling depending on axial symmetry, corresponding sizes and crowning features was designed, and the paintings were inserted into these spaces. Magnificent as the sight must have been – and we can get a good idea of the appearance of the imperial gallery in Charles VI's reign as the emperor asked Ferdinand Storffer to produce a painted picture inventory in three volumes (1720, 1730, 1733) – the system must likewise have been rigid, affording no opportunity for additions or change. The large dedicatory picture (*Charles VI and Count Gundaker Althann*) by Francesco Solimena indicates how much importance Charles VI must have attached to the reorganization, completed in 1728.

The self-imposed inflexibility of the painting gallery with its decorative grandeur may also have been a factor in the emperor's decision not to buy Prince Eugene's superb collection of paintings. The place where this was exhibited, Prince Eugene's summer palace of Belvedere, then outside the city walls, bought by Maria Theresa in 1752, was nonetheless to play an important role for the imperial collections. However, we must first turn to the acquisitions made by Empress Maria Theresa (1717-80) and her son Emperor Joseph II (1741-90), which in any case directly led to the transfer of the gallery to the Belvedere. It may seem inappropriate to describe Maria Theresa as a connoisseur or even a lover of painting in view of the many astonishing sales from the collections – despite the sequence of views of Vienna and the Habsburg castles painted for the court by Bernardo Bellotto (Canaletto). All the same, from the early 1770s work started on rearranging the imperial picture collection. At this period of general animation in the art world the practical

corollaries regarding the position of the arts in an 'enlightened' state were becoming apparent: general access to the collections for the instruction and edification of a country's subjects implied different exhibiting principles based on didactic and historical considerations and scholarly research into the collection.

Important acquisitions from Flemish churches occurred in the middle of this reorganization, i.e. between 1775 and 1781, also entailing a general change in the function of the collection. Some of these were huge altarpieces by Rubens, Van Dyck and de Crayer from the suppressed Jesuit colleges and other churches in the Austrian Netherlands, and, for instance, Caravaggio's *Madonna of the rosary* from the Dominican church in Antwerp. As well as paintings from the Austrian Netherlands altarpieces were also acquired in Italy and Vienna and are now a striking component of the Baroque sections of the Vienna Paintings Collection. In none of theses cases is it really possible to detect personal taste or preference. There is rather a concern that valuable examples of artistic creativity might be lost as a result of disruptive church reforms, and even a need to assign to these same works, characterized by their now secularized evidential nature, an ideal showplace in a museum intended for the edification of the population at large. The memory of the Habsburg ancestors who had ordered Rubens's *Ildefonso altar* may also have played a role in buying it for the imperial collection. However, there was simply no further space in the old Stallburg for these pictures, most of them large in format. Therefore in 1776 Maria Theresa arranged for the complete imperial paintings collection to be transferred to the Belvedere.

In 1778 Joseph II appointed the Basle engraver and art dealer Christian von Mechel, whose brief it was to use Schloss Belvedere in such a way 'that the interior overall and its component parts should be instructive … and become a visible history of art'. The work was completed in 1781, and in 1783 the printed *Verzeichniss der Gemälde* (Catalogue of paintings), prepared in French and German by von Mechel himself, was published, 'the first catalogue drawn up according to modern principles, serving both the public and the specialist … of all the collections subsequently assembled in the Kunsthistorisches Museum' (A. Lhotsky). The pictures were arranged historically by schools, displayed in unified, Josephine frames, and the rooms themselves were labelled in the two languages. The gallery was accessible to the general public three times a week, though only 'with wiped shoes', and not to children or on rainy days. The spirit of Winckelmann can be discerned in the programme, the pedantry of enlightened despotism in the detail.

It is really a little unjust to view the often deplored exchange of pictures that took place between 1792 and 1821 in the reign of Emperor Francis I (1768-1835) between the imperial collections in Vienna and what were then the Habsburg-Lorraine galleries in Florence in purely negative terms. The plan of filling gaps in the historical collection was typical of the period; all the same, blunders and real losses (e.g. Dürer's *Adoration of the kings* and Titian's *Flora* in the Uffizi) discredited the scheme, when it is viewed with hindsight. On the other hand the acquisitions of works from the sixteenth and seventeenth centuries in Florence fit into the Viennese collection extraordinarily happily.

The nineteenth century as a whole, ushered in by Napoleon's conquest of Vienna in 1809, with Napoleon's art commissioner Vivant Denon having 400 of the pictures which it had not been possible to put into safekeeping beforehand carried off to France, meant an almost complete standstill where acquisitions were concerned. While both London and Paris and – especially in the second half of the century –

the large German museums, with Berlin at the forefront, were able to expand their stocks systematically by buying entire collections or acquiring specially selected items, the crucial purchases of old art for the imperial collection in Vienna can be counted on the fingers of both hands. While it looked at first as if the intention was to expand the nucleus of Dutch painting from the 'Golden Age' which had been formed primarily in the latter part of the eighteenth century, as time went by the imperial family refrained from making further purchases, in spite of the wealth of paintings that were in private ownership in Vienna at that period. However, anything that was bought in the nineteenth century tended to reinforce still further the strengths of the existing collection.

The appearance of the Vienna gallery, which was the private property of the imperial family up until 1918, therefore remained more or less completely unchanged in the nineteenth century. Indeed in 1875 'wise management taking account of the basic collection which in many areas is incomparable' was expressly required in the context of a 'general programme', and the aim was 'to give precedence to achieving excellence within narrow … parameters rather than striving for nebulous aims and collecting in every direction'. There were thus never to be great financial means available, in view also of the private nature of the collection. Museum cupidity such as could be observed elsewhere was never able to become established in Vienna; the historian Alfons Lhotsky, writing this century, aptly commented '… the principles and passions of philately never permeated through to the imperial collections'. Every one of the subsequent republican governments of Austria has adhered to that guideline, even if by default.

Attention was turned instead to the internal and external rearrangement of all the works of art owned by the Habsburgs, and to bringing them together under one roof, in the Kunsthistorisches Museum built between 1871 and 1891 by Gottfried Semper and Karl Hasenauer on the Emperor Franz Joseph's boulevard, the Ring. At the same time real historical and art-historical research on the Paintings Collection got under way. The basis for this was the exploration of the history of the collection by means of archival studies. It is indicative that Leopold Wilhelm's 1659 painting inventory was published for the first time in the first volume of the 'Allerhöchstes Jahrbuch' (*Jahrbuch der kunsthistorischen Sammlungen der Allerhöchsten Kaiserhauses* [Yearbook of the art history collections of the Supreme Imperial House], after 1918 *Jahrbuch der kunsthistorischen Sammlungen in Wien* [Yearbook of the art history collections in Vienna]), the museum's house publication which appeared from 1883. The *Beschreibendes Verzeichnis der Gemälde* (Descriptive catalogue of the paintings) written between 1883 and 1886 by Eduard von Engerth, the director of the gallery and a painter, is still an indispensable reference work today.

While the historicist grandeur of the newly built Kunsthistorisches Museum and the hanging of the pictures in the gallery opened in 1891 – although carried out in line with historical considerations it was nonetheless decorative, with pictures set into the plasterwork of the gallery walls – conjured up memories of the reorganization carried out in Charles VI's reign, there was then a counter-reaction at the beginning of this century towards progressive and possibly purist ideas. Where museum practice was concerned, as in almost all great painting galleries, there was a move away from decorative hanging with several rows of pictures one above the other, and everything that was not considered absolutely valuable and essential for the public at large was banished into store-rooms that were accessible only to specialist researchers. Starting from the premise that individual works of art can be shown to

advantage only to some extent in isolation, a wide range of different compromises between decorative, symmetrical hanging and historical, chronological hanging have been tried out since, while respecting historical connections, and generally in a single row. However Viennese gallery officials, with their own sense of historical continuity and their trained memory, introduced what is known as the secondary gallery in the late 1960s, a store room accessible to all on the walls of which a Baroque painting gallery is conjured up, with the pictures superimposed in several rows and arranged in a decorative, symmetrical manner.

Collecting now got under way, first and foremost under the curatorship of the great art historian Gustav Glück (1911-31) but to some extent after World War II as well; it was successfully pursued, albeit on a modest scale compared with the great galleries in other countries. Glück formulated the following programme:

> Our efforts should be directed towards ensuring that new additions fit in with the priceless nature of the existing stock, connecting with it in perfect harmony, and that the new does not attempt to outshine the old; it will in any case never be able to exceed its splendour. A certain conservatism is surely appropriate here, but it must not lead to a total lack of life.

Thus the collection of Italian seventeenth-century and more particularly eighteenth-century painting was considerably expanded in spite of very modest resources, and often only by means of exchange (in itself a thorny issue). The two large *Histories* by Giovanni Battista Tiepolo from the Ca' Dolfin in Venice or the monumental historical allegory (*Astraea leaving the earth*) by Salvator Rosa may be cited as representing this policy. The Dutch section became more broadly based as well as acquiring outstanding works such as Frans Hals's *Tieleman Roosterman*, one of Clarisse de Rothschild's gifts, or Jan Vermeer's famous studio picture (*The artist in his studio*), formerly the showpiece of Count Czernin's collection. Among acquisitions in the field of German painting mention should be made first and foremost of works from the Danube School as well as of Dürer's *Portrait of a young Venetian woman*. For the first time a number of excellent English paintings were also bought. Among Flemish paintings the acquisition of the head of a young man (*Vincenzo Gonzaga*) and its brilliant attribution or identification as part of Rubens's Trinity altar from Mantua may be mentioned.

Nonetheless, no attempt has ever been made to reshape the collection handed down to us, so the tight-fistedness of state bodies where purchases are concerned, painful and irksome as missed opportunities are, may also have a good side. And in the last two decades in particular considerable financial resources have for the first time been made available for the technical modernization of the gallery in terms of air-conditioning and security, and the establishment of restoration workshops conforming to international standards.

Any attempt to summarize the overall character of the Paintings Collection of the Kunsthistorisches Museum is certainly not easy, though it is perhaps easier than it would be in the case of the other great collections of paintings on either side of the Atlantic: easier because the collection has such a specific internal form and because it is so closely associated with the countries over which the ruling house, the Habsburgs, reigned for some 500 years. The pictures crucial to the collection come from Germany, the Catholic Southern Netherlands and North Italy, while

Francesco Solimena
Canale di Serino/Avellino
1657- Barra/Naples 1747
*Charles VI and Count
Gundaker Althann*, 1728,
signed and dated
Canvas, 309 x 284 cm
(Inv. no. 1601)
Painted for Charles VI

Count Althann (1665-
1747) is handing
Emperor Charles VI
(1685-1740) the inventory
of the picture gallery just
installed in the Stallburg
in Vienna. The figure of
Fama is proclaiming the
emperor's appreciation
of art to the four corners
of the world. The portrait
heads of the 'Emperor
and his Minister of
Buikdings' were painted
in Vienna by Gottfried
Auerbach (1697-1753).
Underneath these heads
X-ray pictures reveal that
Solimena's faces, not
resembling portraits and
differently set out, are
still preserved.

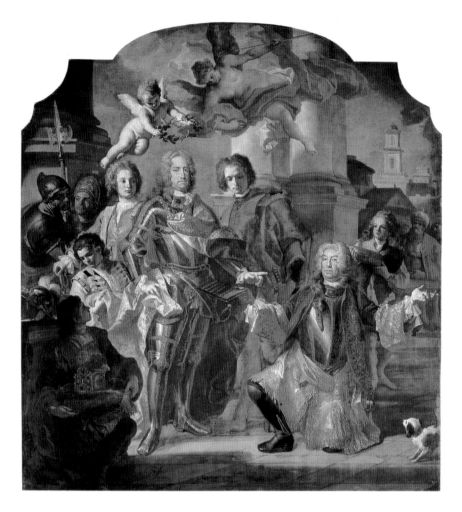

France, Holland, England and the Italian city states of the later Middle Ages remain outside its scope. The few Spanish pictures have a special status. As great overlords the Habsburgs liked what was completed, not things in a state of sometimes awkward development. There are few works from the 'early' stages of stylistic trends, works striving only towards internal completeness, nothing from the thirteenth and fourteenth centuries, scarcely any works from the Italian Quattrocento, no 'struggling brooders', and very few sketches. They liked mature or overripe styles, the Venetian and Flemish sixteenth and seventeenth centuries, the fully elaborated, perfect, even decorative item, nothing eccentric, but things that were arranged with refinement, elegant as a matter of course, but not boastful. The collection itself is conceived as a decorative whole. The Habsburg taste is 'devout' without declining into bigotry, and the erotic impetus, though perhaps not quite as strong as in the case of their Spanish cousins, plays a major role; in any case prudishness did not trouble the Habsburgs until relatively late. All the great collectors from the House of Habsburg loved the Early Netherlandish painters, Bruegel, Titian and Dürer, and from a later period Rubens and Van Dyck. To this day The Vienna Paintings Collection bears the hallmark of their 'family taste', one-sided as it may have been.

Italian Painting

Painting from the Romance countries, Italy in particular, occupies the whole first floor of the west wing of the Kunsthistorisches Museum. The merits as well as the lacunae in the stock of Italian pictures can be explained by the history of the collection and the taste of the Habsburg collectors which remained constant throughout the centuries. Venetian painting, the painting of the Terra Ferma in the sixteenth century, is complete in the full range of its possibilities, and the Mannerist art of central Italy is well represented. Every aspect of Caravaggesque realism can be studied, just as all the centres of Italian Baroque painting are exemplified by superb works, with Upper Italian painting dominating both in quantity and quality, though south Italian art is also very well represented. As against this there is a striking, almost total lack of Italian 'Primitives'.

The main exhibit among works from the late fifteenth century is the monumental fragment of what is known as the *Pala di San Cassiano* by Antonello da Messina, who originated from Sicily. Even in its fragmentary state the first manifestation of this type of altar and the importance of the *Pala* which attracted a school of followers can still be appreciated, and Antonello's interest in the material appearance of the surface resulting from his contact with Early Netherlandish painting in association with a downright cubic corporeality can be admired. Measured against the painterly brilliance of this picture Gentile Bellini's painted tabernacle door created at the same period for a reliquary containing a piece of the True Cross (*Cardinal Bessarion before his reliquary containing a piece of the True Cross*) may appear dry. The humanist Cardinal Johannes Bessarion had donated the reliquary to the Scuola della Carità in Venice. Nonetheless it is of supreme historical importance as evidence of the links between Venice and Byzantium embodied in a biographical sense by the Greek cardinal. Gentile Bellini's style was formed primarily under the influence of his brother-in-law Andrea Mantegna. Mantegna's *St Sebastian*, which is signed with Greek letters, conjures up a stony Antiquity, a world constructed in accordance with strict rules; in it the Christian saint of the plague is seen as a marble sculpture, demonstrating the specifically archaeological humanism of the painter's Paduan homeland.

The long series of sixteenth-century Venetian masterpieces begins with Giorgione and ends in the ramified output of the Bassano family and their studio. But Giorgione, Titian, Tintoretto, Veronese and Lotto are still the central figures. In varying degrees and with a time lapse of 60 years, the idea of classical harmony in the unity

Titian, properly
Tiziano Vecellio
Pieve di Cadore
c.1488/90 - Venice 1576
Jacopo de' Strada, 1567/8,
signed
Canvas, 125 x 95 cm
(Inv. no. 81)
Archduke Leopold
Wilhelm collection 1659

The sitter (Mantua 1515? - Vienna 1588) was one of the most versatile and shrewd personalities of the sixteenth century. Around the middle of the century he served Duke Albrecht V of Bavaria as an art adviser, then he was at the papal court and from 1557 in the service of the Habsburgs. A painter, architect, goldsmith, archaeologist, philologist, art collector and art dealer, he was indispensable to his various masters as an antiquarian and buyer of objects of art.

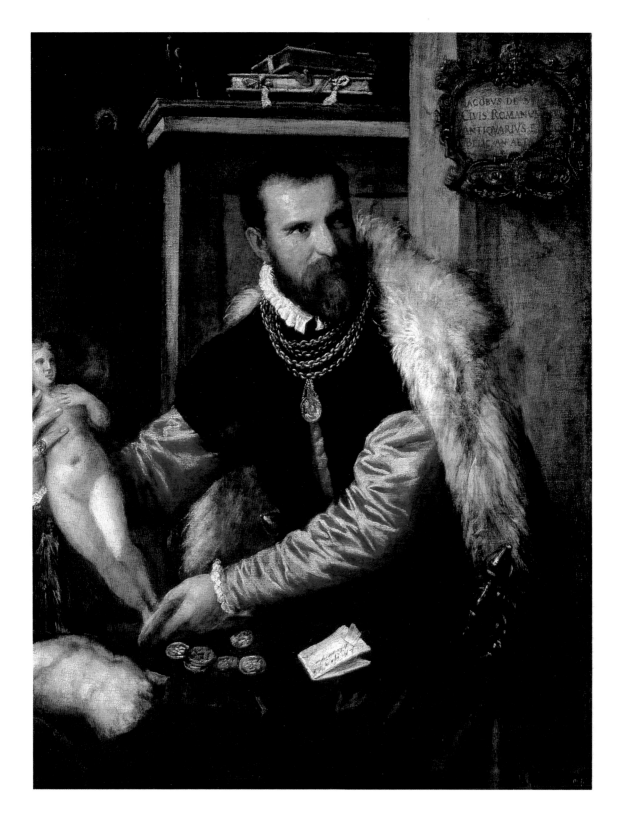

between the human being and the landscape – the fusion goes to the point of veiling the contents of the picture – is the formative influence behind Giorgione's *The three philosophers*, painted in 1508 and still iconographically equivocal, and Titian's *Nymph and shepherd*. Apart from this late work Titian's œuvre is represented in all its facets, from his Giorgionesque beginnings with *The gypsy Madonna* by way of *Ecce homo*, the 'Baroque' masterpiece of his middle period, to the fascinating late portrait of the agent, art dealer and scholar *Jacopo de' Strada*, with its virtuoso play on the dubious character of the sitter by means of colour and composition.

Among the Tintorettos in the Paintings Collection portraiture is the dominant genre, starting with the relatively early portrait of the Venetian senator *Lorenzo Soranzo* with his melancholy demeanour, a portrait which is particularly appealing because of its skilful concentration on the individual features of the person portrayed. The central work however is *Susanna at her bath*, a bold composition bursting with energy, full of contrasts between light and shade, old and young bodies, clothed and naked bodies, dense vegetation and mirroring water, close-up and distant views.

The special merits of the youngest of the Venetian triad formed by Titian, Tintoretto and Veronese can be seen to special advantage in the collection in Vienna. Paolo Veronese's ability to structure even large picture surfaces in a surprising yet harmonious way without doing violence to his natural talent, his virtuoso colour magic, his merits as a decorator in the best sense of the word were highly esteemed in the seventeenth and even more in the eighteenth century; he was one of the great sources of inspiration of painting both inside and outside Italy. In his late work, in *Hercules, Deianira and the centaur Nessus* for example, his palette becomes darker, and the object depicted is less strongly subordinated to the overall decorative impact.

The poetry tinged with melancholy which is the atmosphere of so many Upper Italian or Venetian pictures is expressed particularly beautifully in Lorenzo Lotto's *Sacra conversatione* and in Moretto's *St Justina*. In portraits, a questioning look in the subject's eyes or the choice of an accessory can heighten this into something puzzling and disturbing, as for example in Lotto's *Young man against a white curtain*.

The painting of Ferrara was always at the intersection of the areas of influence of Venice and central Italy, and thus in the fifteenth and earlier sixteenth centuries between the art of Andrea Mantegna, heightened in the work of Cosimo Tura for example into the ecstatically expressive, and the ideal, tranquil corporeality of Raphael. In the work of Dosso Dossi this has a peculiarly excited and unclassical note owing to the glowingly rich Venetian colouring.

It is virtually inevitable in the old art theory dispute between *disegno* and *colore* – between Florence or Rome and Venice, between the followers of the clearly defined art form with its genesis in the intellect, superelevating nature, and the lovers of colour which dissolves boundaries – that the scales should come down on the side of *colore* in the Vienna Paintings Collection. All the same, in Raphael's *Madonna in the meadow* and in the works of Fra Bartolomeo, Andrea del Sarto and Bronzino the Kunsthistorisches Museum owns very representative examples of the other side of the argument. While in the *Madonna in the meadow* created in 1505/6 we recognize the classical embodiment of the Italian High Renaissance expressing itself in ideal naturalness of form, in a geometrically regular pictorial world which is nonetheless animated from within, Andrea del Sarto (*Lamentation of Christ*) provides a new intense expression of emotion, a special insight into religious feeling. As well as composition the main vehicles are the painterly means used by Leonardo, the soft *sfumato* enveloping the precisely drawn figures brought close to the viewer.

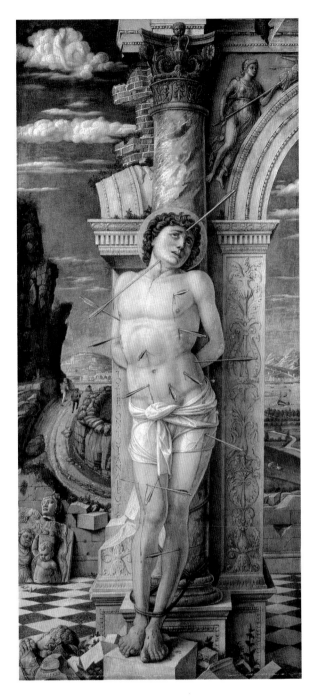

Andrea Mantegna
Isola di Cartura/Padua 1431 - Mantua 1506
St Sebastian, c.1459,
signed in Greek letters on the pillar on the left
Panel, 68 x 30 cm (Inv. no. 301)
Archduke Leopold Wilhelm collection 1659

Probably painted for Commander Jacopo Antonio Marcello
(1398 - after 1461), one of Mantegna's friends from the
humanist circle in Padua. In spite of the atmosphere of
Antiquity, Sebastian must surely be perceived primarily as
a saint of the plague, which may also be indicated by the
Horseman of the Apocalypse depicted in the sky.

Gentile Bellini
Venice *c.*1431 - Venice 1507
*Cardinal Bessarion before his reliquary containing
a piece of the True Cross, along with two brothers
of the Scuola della Carità in Venice,* 1472/3
Panel, 102.5 x 37 cm (Inv. no. 9109)
Until the eighteenth century in Venice, Scuola
della Carità, the present Accademia delle Belle
Arti, gift of Erich Lederer 1950

Painted door of the tabernacle which Cardinal
John Bessarion (*c.*1395-1473) had made in 1472
to receive the reliquary rescued from Byzantium
and depicted on the door.

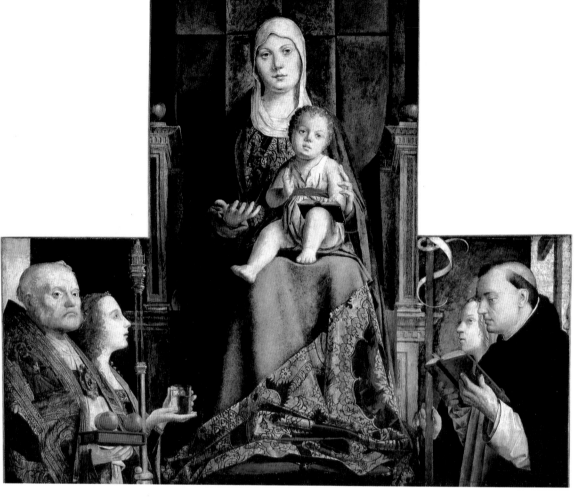

About the middle of the century Bronzino embarked on a different path, leading from painting to sculpture: in the *Holy Family* he purifies the bodily forms to the point where they can seemingly almost be touched as stone. Marmoreal coolness and high artifice are the trademarks of this concept of a refined approach to painting in the Florence of Grand Duke Cosimo I.

The pictures by Correggio and Parmigianino, the supreme master of Mannerist painting in Emilia, are among the oldest possessions of the Vienna Paintings Collection. In the case of Correggio's *Loves of Jupiter*, major examples of his sensualist painting which remained in the imperial collections, and in the early *Self-portrait in a convex mirror* by Parmigianino – with its virtuoso conception and execution ideally suited to be a present from the precocious artist to Pope Clement VII – the provenance can be traced through all the intermediate stages back to the artists themselves.

In Lombard painting of the sixteenth and seventeenth centuries the visible, reality which can be conveyed by optical means, the precise representation of what is, was always a prime concern on the one hand, while on the other Lombard painters were able to give expression to religious ecstasy, extreme spiritual conditions, and psychological reality, complementing the visible, particularly in the age of the Counter-Reformation. Of course at the same time Leonardo da Vinci, that great

Antonello da Messina
Messina *c.*1430 -
Messina 1479
*Madonna with SS Nicholas
of Bari, Anastasia (?),
Ursula, Dominic and Helen*,
fragment, 1475/6
Panel, 115/56 x 133.6 cm
(Inv. no. 2574)

The *sacra conversazione* where the Virgin enthroned was surrounded by eight saints, was commissioned by the Venetian patrician Pietro Bon for San Cassiano in Venice, removed from the church in 1620, sawn into pieces before reaching the Leopold Wilhelm collection.

Giorgione, properly
Giorgio da Castelfranco
Castelfranco Veneto
*c.*1476/8 - Venice 1510
The three philosophers,
*c.*1508/9
Canvas, 123.8 x 144.5 cm
(Inv. no. 111)
Mentioned in 1525 in
the house of Taddeo
Contarini in Venice.
Archduke Leopold
Wilhelm collection 1659

From 1525, when the
picture was reportedly
described as 'Three
philosophers in a
landscape ... with those
so marvellously painted
rocks', until today,
discussion over the
precise content of the
picture has not abated:
the three ages of man, the
representatives of three
philosophical movements
or mathematical schools,
or the Three Magi. The
novelty and the intensity
of Giorgione's expressive
means – colour, light,
mood, i.e. optical and
psychological phenomena
going beyond calculable
perspective – continued
to have a powerful impact
in Venice throughout the
century.

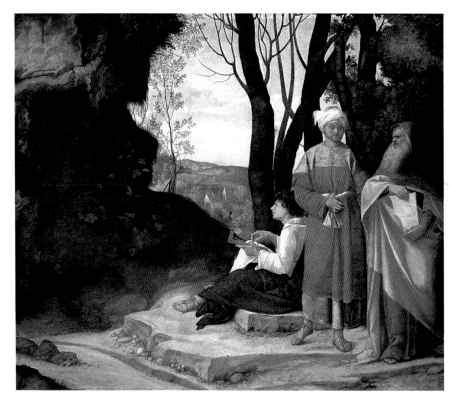

observer of nature, attracted a considerable following in Lombardy. The Paintings Collection owns a brilliant example of this in the form of Cesare da Sesto's *Salome with the head of John the Baptist*. Counter-Reformation painting in Lombardy is characteristically represented in the collection by Giulio Cesare Procaccini and Cerano. The Lombard painter Giuseppe Arcimboldo, who worked in the service of Emperor Maximilian II and Emperor Rudolf II, is a special case; he assembled his precisely observed and 'drily' reproduced particles of reality into fantastic, cappriccio-like allegories.

Italian Baroque painting gets into full swing, in the Vienna Paintings Collection too, with the Lombard artist Michelangelo Merisi da Caravaggio and Annibale Carracci from Bologna, though both of them created their major works from about 1600 in Rome or southern Italy. One of the main pictures from Caravaggio's late period, *The Madonna of the rosary*, which must have been painted in 1606/7 in Naples, stands at the centre of the collection of Caravaggesque works comprising all local and stylistic aspects of his following. In conscious contrast to the art that had preceded him Caravaggio achieves a direct impact on the viewer by the overwhelming immediacy of all protagonists: his artistic means are sharp *chiaroscuro* contrasts which make one feel his figures could be touched and extreme verism in reproducing what can be seen. Caravaggio's influence on the development of painting was crucial, especially in Naples (Giovanni Battista Caracciolo), the Netherlands, France (Valentin de Boulogne) and central Italy where the Tuscan Orazio Gentileschi in particular contributed to disseminating Caravaggesque pictorial ideas.

Nature, albeit ideally seen and elevated, was the point of departure for Annibale Carracci and his Bolognese and Roman students Guido Reni, Giovanni Lanfranco and Guercino. He is represented in Vienna by his late *Pietà* with its very tranquil classicism. Apart from late Annibale Carracci, among the Bolognese painters of the seventeenth century it is Guido Reni who comes closest to classicism in his harmonious composition and the idealized nature of those he depicts. In his *Baptism of Christ* painted about 1620, the pathos is tempered by the differentiated tonal values and the gentleness of the drawing. In *The return of the prodigal son*, an early contemporary work by Guercino, the artist demonstrates with verve how the Bible story can be dramatically staged, with the restlessly applied *chiaroscuro* fragmenting the bodies and the powerful colour contrasts between coloured areas of penumbra.

Later painting in Emilia can be studied particularly well in Vienna, mainly thanks to two great patrons of the arts. Archduke Leopold Wilhelm and Emperor Leopold I summoned Guido Cagnacci to the Viennese court in 1657. In the *Suicide of Cleopatra* Cagnacci contrasts keenly observant realism in the body language of the weeping and distraught women attendants with the classicism of Cleopatra, sitting calm and relaxed. The subtle colour composition and the soft light merging the tonal values endow the picture with a markedly sensuous character. Forty years later Prince Eugene of Savoy employed a whole band of Bolognese painters to decorate and furnish his winter residence in the Himmelpfortgasse in Vienna. The most interesting of these was Giuseppe Maria Crespi; the *chiaroscuro* in his overdoor depicting *Aeneas with the Sybil and Charon* serves to model the bodies with plasticity, and above all to structure the surface of the picture into light and dark patches, into bands of light, as if the physical connection and hence the connection with regard to content were becoming secondary – pointers to the new century that was about to start.

In the collection of Florentine Baroque painting, which can scarcely be matched

Giorgione,
properly **Giorgio da Castelfranco**
Castelfranco Veneto *c.*1476/8 -
Venice 1510
Portrait of a young woman ('Laura'),
1506, dated on the back
Canvas on panel, 41 x 33.6 cm
(Inv. no. 31)
Archduke Leopold Wilhelm
collection 1659

A seventeenth-century designation –
plausible because of the sprig of laurel
(*lauro*) in the picture – may refer to
Petrarch's Laura; possibly the laurel is
an allusion to faithfulness and modesty,
virtues which the person commissioning
it, named on the back as 'Messer
Giacomo', wanted to have attributed to
the woman portrayed. Be that as it may,
Giorgione here created the prototype for
later portraits of courtesans in Venetian
painting, for example in the work of
Titian, Palma Vecchio and Paris Bordone.

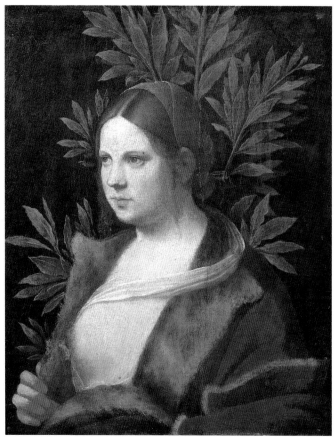

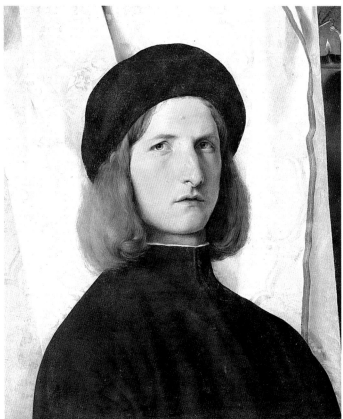

Lorenzo Lotto
Venice 1480 - Loreto 1556
*Portrait of a young man against
a white curtain, c.*1508
Panel, 42.3 x 35.3 cm
(Inv. no. 214)
In Paintings Collection in 1816

A surface realism derived from northern
painting (Dürer was in Venice in 1505/6), the
graphic sharpness, and the way psychological
phenomena are made visible to the point of
becoming irritating (the little oil lamp in the
top corner!) distinguish this puzzling portrait
from the ideal portraits of the high Renaissance.

outside Florence in its scope, special attention may be drawn to Jacopo da Empoli's *Susanna*, painted in 1600. All the virtues of this school are already apparent here: graphic clarity, refinement and sensuousness in the combination of colours, a gentle gradation of tones in spite of bright colourfulness, a powerful, almost stereometric plasticity as a legacy of the great past, and a particular, almost big-city swagger in the slightly mannered elegance of the poses. And although Pietro da Cortona must really be regarded as the leading master of Roman High Baroque, not only was he a Tuscan by birth and training, but in the 1640s he also created an extremely important fresco cycle in the Palazzo Pitti in Florence, at the period when the *Hagar's homecoming* in Vienna must have been painted.

Neapolitan painting of both the seventeenth and eighteenth centuries can be studied particularly well in Vienna. It was collected over all periods, ranging from the strictly Caravaggesque *Christ's Agony in the garden* by Giovanni Battista Caracciolo from Archduke Leopold Wilhelm's collection by way of the cabinet pictures of Bernardo Cavallino – certainly the gentlest and in painterly terms the most subtle of the sometimes verbose Neapolitans – and Salvator Rosa's *Astraea* allegories centred on the theme of the Golden Age, to the works of Luca Giordano and Francesco Solimena. The Vienna museum possesses seventeen works by Giordano alone. Here we may mention the huge early altarpiece with the *Archangel Michael* originating from the Minorite church in Vienna, still strongly influenced by Ribera, and Solimena's late *Descent from the Cross* painted for Prince Eugene of Savoy.

As might virtually be expected, the Vienna collection is particularly rich in Venetian Baroque painting. Domenico Fetti and Bernardo Strozzi are impressively represented by thirteen and five works respectively, most of them originating from Archduke Leopold Wilhelm's collection. Fetti's great painting skill can be admired especially in the small mythologies which must originally have been used to decorate a piece of furniture. Strozzi was probably the most talented decorative painter of

Titian, properly **Tiziano Vecellio**
Pieve di Cadore
*c.*1488/90 - Venice 1576
The gypsy Madonna,
*c.*1510/11
Panel, 65.8 x 83.5 cm
(Inv. no. 95)
Archduke Leopold
Wilhelm collection 1659

Already in this early work, still strongly influenced by Bellini and Giorgione, Titian's distinct individuality is revealed: an energetic grasp of corporeality, extremely subtle gradations of colour which model the volume of the objects depicted, and an unsurpassed surface sensuousness.

Giovanni Bellini
Venice *c.*1433-
Venice 1516
Young woman at her toilet,
1515, signed and dated
Panel, 62 x 79 cm
(Inv. no. 97)
Archduke Leopold
Wilhelm collection 1659

In this late work by
Bellini the taste of the
following generation of
painters, of his pupils
Giorgione and Titian,
also shows up in the
subject depicted. The
attempt to combine the
landscape and figure
by means of colour and
generate a unified,
almost dreamy mood
is typically Venetian.

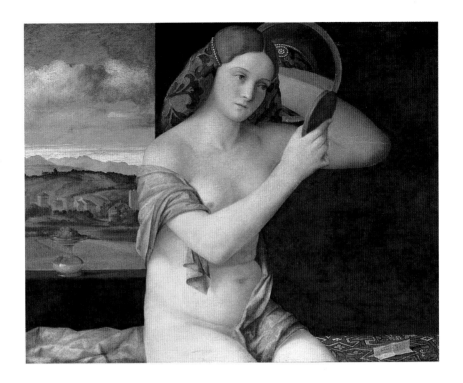

the Seicento in Upper Italy. His luminous colouring with its effective use of the single touch of colour made its influence felt in the eighteenth century in particular. Girolamo Forabosco's *Portrait of a Venetian woman*, which in terms of colouring must be the most refined portrait of the seventeenth century from Venice and Padua, was obviously already highly prized by Archduke Leopold Wilhelm.

Pictures from the eighteenth century in Italy, in Venice in particular, were mainly commissioned directly from the artists, for instance Pompeo Batoni, Gregorio Guglielmi or Bernardo Bellotto (Canaletto), or came into the collection only at a later stage, generally in the twentieth century. The ten-part decoration that Giovanni Battista Tiepolo created for the hall of the Ca' Dolfin in Venice is now broken up, with paintings in St Petersburg, New York and Vienna, Vienna owning the *Death of the consul Brutus in single combat with Aruns* and one other picture. It represents the pinnacle of Tiepolo's early style of about 1728/30 when he worked with powerful *chiaroscuro* contrasts. Bellotto, the most important Venetian painter of *vedute*, in Vienna from 1758 to 1761, creating thirteen views of the imperial capital and the imperial castles in the surrounding area. For example the view of *Vienna, seen from the Belvedere Palace* is translated into a strict, unified pictorial order with impeccable precision, yet Bellotto manages to soften the severity in a demonstration of colouring skill and painterly subtlety.

Apart from portraits there are few pictures from the Italian classicist period with a narrative content in the Vienna collection. One exception is the *Return of the prodigal son* by Pompeo Batoni, purchased directly from the artist in Rome in 1773, a work full of measured pathos; it demonstrates exemplary graphic precision as well as great painterly knowledge.

Lorenzo Lotto
Venice 1480 -
Loreto 1557
*Virgin and Child with
SS Catherine and James
the Greater, c.1527/33*
Canvas, 113.5 x 152 cm
(Inv. no. 101)
In imperial possession in
Vienna in 1660

This unusually human
sacra conversazione is typical
of the loner Lotto; it is
more reminiscent of an
atmospheric open-air
picnic than the ceremonial,
hierarchically arranged
juxtaposition of the Virgin
and saints.

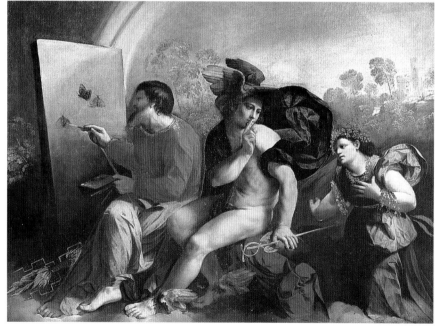

Dosso Dossi, properly
Giovanni de' Luteri
Ferrara 1489 - Ferrara 1542
*Jupiter, Mercury and 'Virtus'
or 'Virgo'*, 1529(?)
Canvas, 112 x 150 cm
(Inv. no. 9110)
Given by Count Anton
Lanckoronski 1951

The picture is based on
a fable recounted by the
Hellenist poet Lucian.
Virtue pursued by Fortune
asks Jupiter for protection,
but Mercury signals to her
to be quiet as Jupiter is busy
painting butterflies (souls).
The picture was interpreted
as having several layers of
meaning, but also with
different meanings. The
richness of the content
complements the charm of
this picture, which is one
of the most poetic works in
Italian painting.

Titian, properly
Tiziano Vecellio
Pieve di Cadore
*c.*1488/90 - Venice 1576
*The girl in the fur, c.*1535
Canvas, 95 x 63 cm
(Inv. no. 89)
Went from Spain into the
possession of Charles I of
England. In Habsburg
possession since 1651

A characteristic portrait of
a courtesan who also served
as Titian's model for other
works; Rubens copied this
painting.

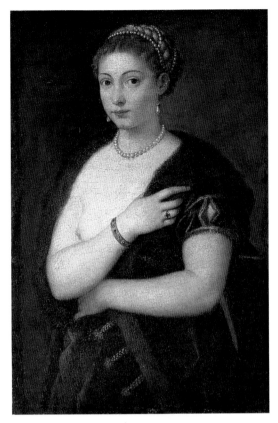

Titian, properly
Tiziano Vecellio
Pieve di Cadore
*c.*1488/90 - Venice 1576
Ecce homo, 1543,
signed and dated
Canvas, 242 x 361 cm
(Inv. no. 73)
Painted for the Flemish
merchant Giovanni d'Anna
(van Haanen) resident in
Venice. In the Duke of
Buckingham's collection
1621- 48. Auctioned in
Antwerp in 1648. Acquired
by Archduke Leopold
Wilhelm for his brother
Emperor Ferdinand III in
Prague; brought to Vienna
on Emperor Charles VI's
instructions in 1723

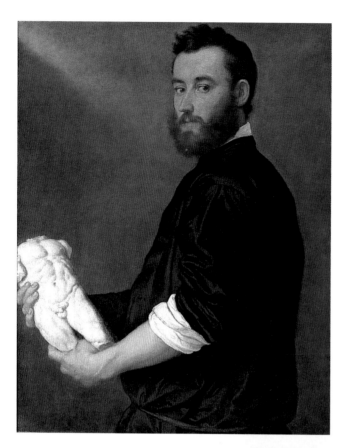

Giovanni Battista Moroni
Albino/Bergamo 1520/24 - Bergamo 1578
The sculptor Alessandro Vittoria, 1552
Canvas, 87.5 x 70 cm (Inv. no. 78)
Archduke Leopold Wilhelm collection 1659

Moroni confronts us with the most important Venetian sculptor of the sixteenth century (1525-1609) at work, letting us participate in his natural pride at the successful revitalization of an antique torso. 'Business portraits' of this immediacy, austerity (in the colour as well) and Lombard precision exerted a powerful influence not only on Moroni's contemporaries – see for example Titian's portrait of *Jacopo de' Strada* – but also later on such artists as Caravaggio and Van Dyck.

Tintoretto, properly **Jacopo Robusti**
Venice, 1518 - Venice 1594
Lorenzo Soranzo, 1553
Canvas, 114 x 95.5 cm (Inv. no. 308)
In the imperial gallery in 1824

Tintoretto painted the portrait of Soranzo (1519-75) in high office since 1551 during his 35th year. For all that Tintoretto's portraiture often stresses mainly the sitter's social status, it can as here also go deeper, suggesting a psychological state of mind and aristocratic spirituality. Portraits such as this later served as models for Van Dyck's portrait art.

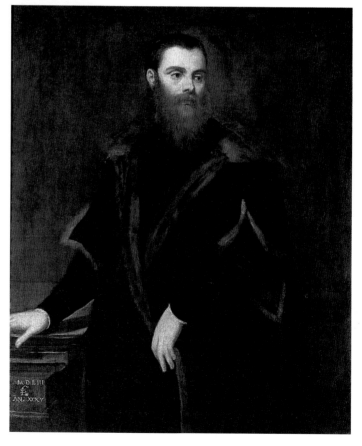

Palma il Giovane, properly **Jacopo Negretti**
Venice, *c*.1548 - Venice 1628
Portrait of a sculptor, *c*.1600
Canvas, 62 x 48.5 cm (Inv. no. 1935)
Archduke Leopold Wilhelm collection 1659

Tintoretto, properly **Jacopo Robusti**
Venice,1518 - Venice 1594
Susanna and the elders, *c*.1555/6
Canvas, 146.6 x 193.6 cm (Inv. no. 1530)
Acquired in 1823

This masterpiece of Venetian Mannerism
is the result of a particular synthesis of a
Romano-Florentine sense of form with the
Venetian approach to painting, concentrating
on the coloured surface and atmosphere.
The ambiguity, indeed the dangerous
nature, of the Old Testament story involving
sexual covetousness, extortion, the rescue of
persecuted innocence and the punishment of
the wrong-doer is depicted before our eyes
down to its ludicrous extremes.

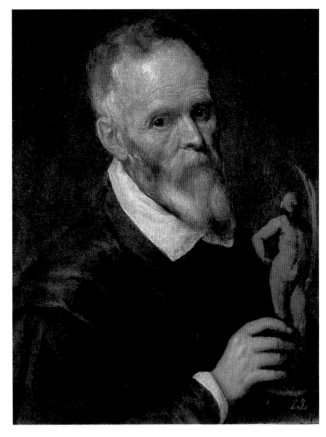

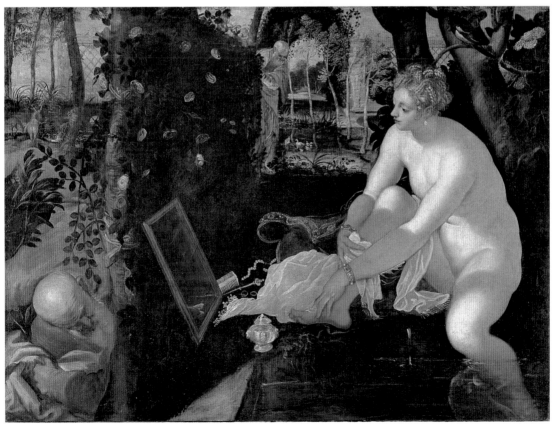

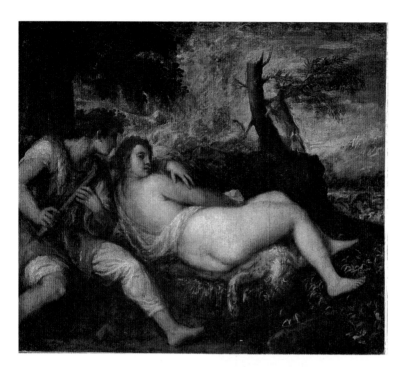

Titian, properly **Tiziano Vecellio**
Pieve di Cadore *c*.1488/90 - Venice 1576
Nymph and shepherd, after 1570
Canvas, 149.6 x 187 cm
(Inv. no. 1825)
Archduke Leopold Wilhelm collection 1659

Various loving couples in a pastoral context from mythology have been suggested, but none of the interpretations is entirely convincing. The picture belongs to the category Titian himself called 'poetries' or 'fables', where the concrete theme retreats behind the mysterious portrayal of a vision of man at one with nature, comprehending all the objects depicted.

Jacopo Bassano,
properly **Jacopo da Ponte**
Bassano *c*.1515 - Bassano 1592
Adoration of the Magi, *c*.1560/65
Canvas, 92.3 x 117.5 cm
(Inv. no. 361)
Archduke Leopold Wilhelm
collection 1659

The head of the Bassano family workshop is seen here at the height of his powers. In an extremely personal variant of international Mannerism, he arranges the traditional protagonists to form an expressive scene full of colour contrasts which is abstractly abbreviated yet realistically cosy and full of formal audacity.

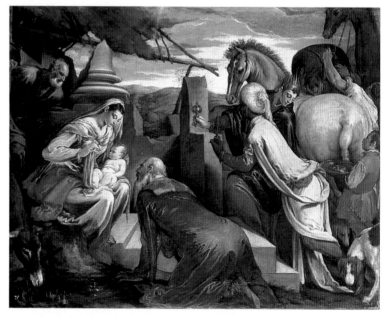

Veronese, properly **Paolo Caliari**
Verona 1528 - Venice 1588
Raising of the youth of Nain, c.1565/70
Canvas, 102 x 136 cm (Inv. no. 52)
Archduke Leopold Wilhelm collection 1659

Veronese, properly **Paolo Caliari**
Verona 1528 - Venice 1588
Judith with the head of Holofernes, 1583/5
Canvas, 111 x 100.5 cm (Inv. no. 34)
Archduke Leopold Wilhelm collection 1659

The theme, the sinister act of the Jewish
heroine who cut off the head of the Assyrian
general Holofernes in his sleep, can only be
identified at a second glance. In the foreground
stands the fair-skinned beauty lavishly depicted
in painterly terms, contrasting with her black
woman servant and the dark head of Holofernes.

Tintoretto,
properly **Jacopo Robusti**
Venice, 1518 - Venice 1594
Flagellation of Christ, *c.*1585/90
Canvas, 118.3 x 106 cm
(Inv. no. 6451)
Acquired in 1923

Fragment of a picture from
Tintoretto's final period, cut
mainly on the left and below: this
period was marked by pictures of
mystic expressiveness. Thus the
scourged figure was not originally
in the middle of the composition.

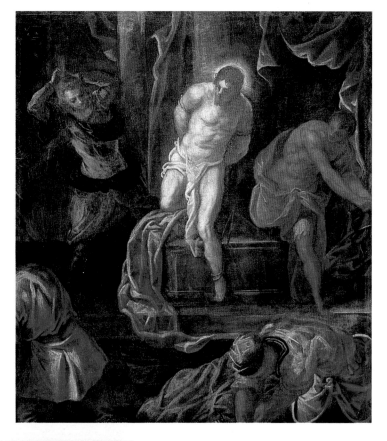

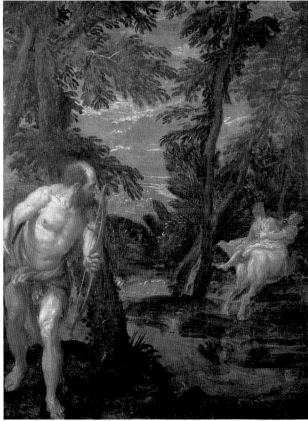

Veronese, properly **Paolo Caliari**
Verona 1528 - Venice 1588
Hercules, Deianira and the centaur Nessus, late work
Canvas, 68 x 53 cm (Inv. no. 1525)
Archduke Leopold Wilhelm collection 1659

Cesare da Sesto
Sesto Calende/Lago Maggiore 1477 - Milan 1523
Salome with the head of John the Baptist, late work
Poplar, 136.5 x 79.6 cm (Inv. no. 202)
Possibly given to Emperor Rudolf II by the
Lombard painter and art theorist Giovanni
Paolo Lomazzo before 1590

The erotic connotations of the cruel end of John
the Baptist which Oscar Wilde and Richard Strauss
were not the first to evoke may have struck a close
chord with the introverted emperor and are suitably
conveyed in the mixture of Leonardo-style *sfumato*
and typically Lombard realism.

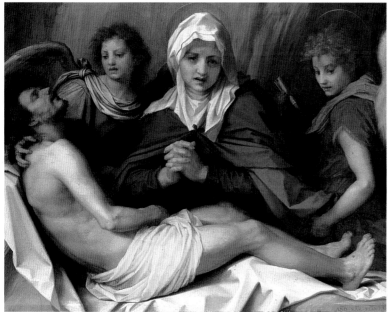

Andrea del Sarto,
properly **Andrea d'Agnolo**
Florence 1486 - Florence 1530
Lamentation of Christ, c.1519/20,
signed
Panel, 99 x 120 cm (Inv. no. 201)
Duke of Buckingham's collection,
1635; bought by Archduke
Leopold Wilhelm for Ferdinand
III in 1648 and sent to Prague;
in Vienna since 1723

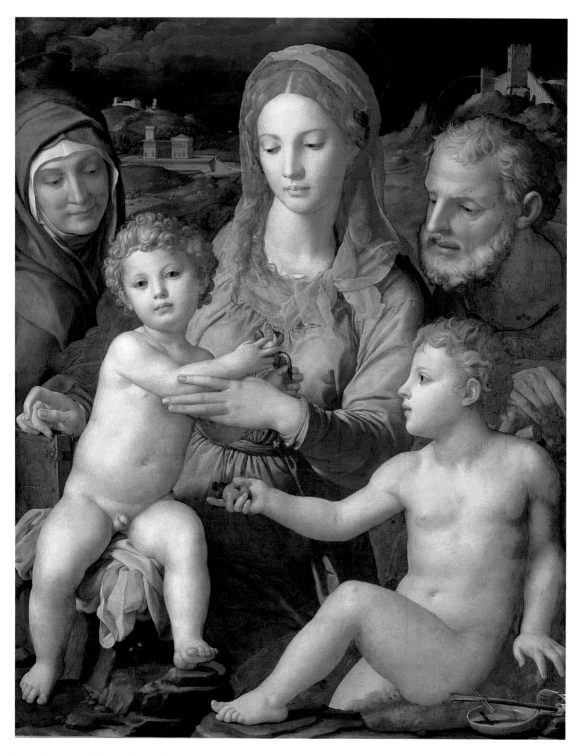

Bronzino, properly **Agnolo di Cosimo**
Monticelli/Florence 1503 - Florence 1572
Holy Family with St Anne and the infant St John,
*c.*1545/6, signed
Panel, 124.5 x 99.6 cm (Inv. no. 183)
Acquired from Florence through exchange in 1792

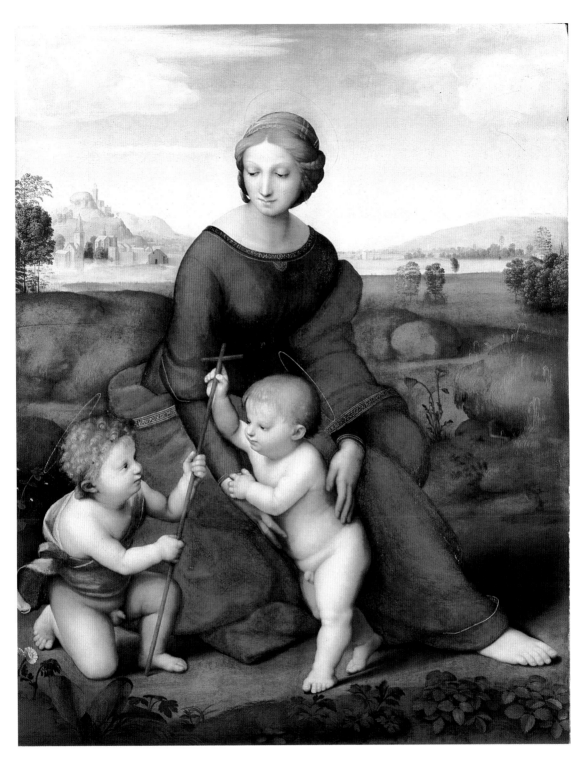

Raphael, properly **Raffaello Santi**
Urbino 1483 - Rome 1520
The Madonna in the meadow (the Belvedere Madonna), dated 1505 or 1506
Poplar, 113 x 88.5 cm (Inv. no. 75)
Painted for Taddeo Taddei in Florence and in the Taddei family palace until 1662. Bought by Archduke
Ferdinand Karl for Innsbruck castle; at Schloss Ambras, Innsbruck, in 1663; in Vienna since 1773

'It is only the sublime beauty of the woman and child that conjures up the idea of the transcendental.
After one and a half thousand years art has again reached the heights where its figures appear as some
thing eternal and divine in themselves, without any additions' (Jacob Burckhardt).

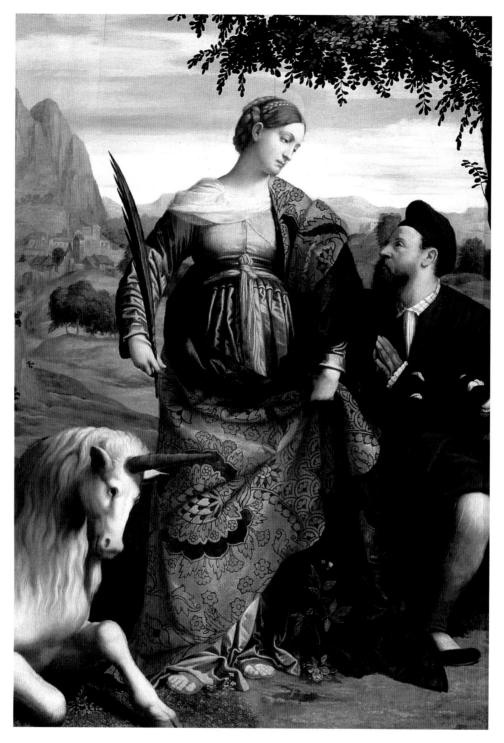

Moretto da Brescia, properly **Alessandro Bonvicino**
Brescia *c.*1498 - Brescia 1554
*St Justina, venerated by a donor, c.*1530
Poplar, 200 x 139 cm (Inv. no. 61)
In the Habsburg collections at Ambras (Innsbruck) in 1663

The fairy-tale atmosphere of this devotional picture lying between rapture and an elegiac love idyll
is certainly inconceivable without the influence of Giorgione and Venice. The monumental formal
language of late Raphael can be discerned in the statuesque, self-composed saint with her classic profile.

Correggio, properly **Antonio Allegri**
Correggio 1489/94 - Correggio 1534
*Jupiter and Io, c.*1530
Canvas, 163.5 x 74 cm (Inv. no. 274)
In Emperor Rudolf II's Kunstkammer in 1601

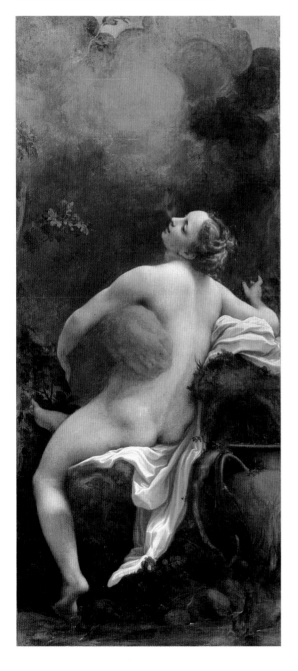

Correggio, properly **Antonio Allegri**
Correggio 1489/94 - Correggio 1534
*Abduction of Ganymede, c.*1530
Canvas, 163.5 x 70.5 cm (Inv. no. 276)
In Emperor Rudolf II's Kunstkammer in 1603/4

Pieces from a four-part series of the loves of Jupiter
which Federico Gonzaga must have presented to
Emperor Charles V in Mantua in 1532.

Parmigianino, properly **Francesco Mazzola**
Parma 1503 - Casalmaggiore 1540
*Self-portrait in a convex mirror, c.*1523/4
On a segment of a wooden sphere, diam. 24.4 cm
(Inv. no. 286)
In imperial possession since 1608, in the Vienna
gallery since 1777

A programmatic masterpiece of Emilian Mannerism
depicting the autonomous artist, in perfect command
of the visual laws, in an ingenious real and illusionistic
constriction of the visual planes.

Parmigianino, properly
Francesco Mazzola
Parma 1503 -
Casalmaggiore 1540
*The conversion of Paul, c.*1530
Canvas, 177.5 x 128.5 cm
(Inv. no. 2035)
Probably painted for
Giovannandrea Bianchi in
Bologna; mentioned in the
inventory of the estate of
Pompeo Leoni in Madrid
in 1608; exhibited since
1917

Parmigianino succeeded
completely in conveying
the spirituality and
psychological tension of
this conversion through
distortion of the proportions,
the unreality of the colours
(the horse's blue eye!) and
the paradisiac utopia of
the landscape in a picture
which, despite its extreme
excitability, is strictly
composed.

Giovanni Battista Crespi, known as **Cerano**
Busto Arsizio 1567/70 - Milan 1632
Christ appearing to Peter and Paul, c.1626/8
Canvas, 274 x 184 cm (Inv. no. 273)
Painted for the church of San Pietro dei Pellegrini
in Milan, probably acquired for the imperial gallery
in 1779

Cerano worked mainly as an architect and painter in
the Milan of Cardinal Federico Borromeo. This large
late work represents the altar painting of the Counter
Reformation. The dematerialized 'transfigured' body
of Christ is set against the heavy, earthly figures of
Peter and Paul in a vision, for the viewer with faith
and the two men depicted. In the background St Peter,
after whom the church in Milan was named, meets
the transfigured Christ yet again and asks him 'Domine
quo vadis'.

Annibale Carracci
Bologna 1560 -
Rome 1609
Lamentation of Christ,
c.1603/4
Copper, 41 x 60.8 cm
(Inv. no. 230)
Archduke Leopold
Wilhelm collection 1659

After 1595 when Annibale
Carracci had been
summoned to Rome by
the Farnese family, his
manner of painting
gradually changed.
Influenced by Antiquity
and the art of Raphael
and Michelangelo, his
style developed in the
spirit of Roman *gravitas*
more towards classical
severity and heroic
grandeur, as in this small
Lamentation.

Caravaggio,
properly **Michelangelo Merisi**
Milan 1571-
Port'Ercole 1610
The Madonna of the rosary,
1606/7
Canvas, 364 x 249 cm
(Inv. no. 147)
On the Naples art market in 1607, in the Dominican church at Antwerp as a donation from a group of artists including Rubens and Jan Brueghel from *c*.1620, acquired from there for the imperial gallery in 1781

The viewer is exhorted and challenged to involvement in the natural yet supernatural process of distributing the rosaries. While the people in the picture see only St Dominic, the believer standing in front of the altarpiece experiences the tangible workings of supernatural mercy in earthly reality: his eyes are directed towards Christ, the source of salvation – the Christ Child stands exactly in the central axis of the picture – and in a good Catholic Counter-Reformation spirit towards Mary and St Dominic, intercessors for mercy.

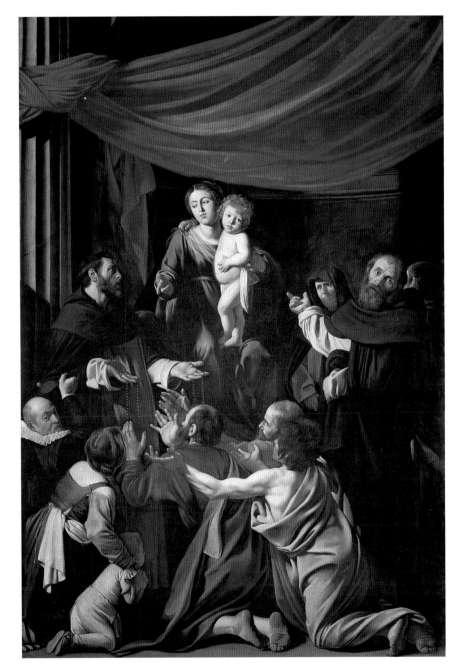

Caravaggio,
properly **Michelangelo Merisi**
Milan 1571-
Port'Ercole 1610
David with the head of Goliath, c.1606
Panel, 90.5 x 116 cm
(Inv. no. 125)
Acquired by Emperor
Leopold I in 1667/70

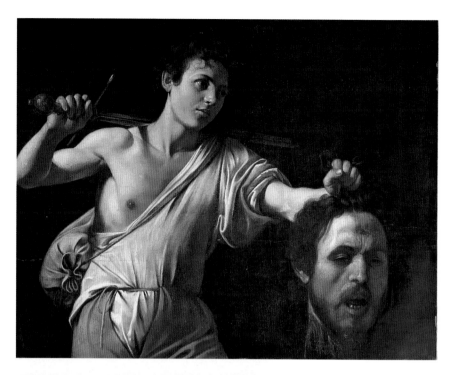

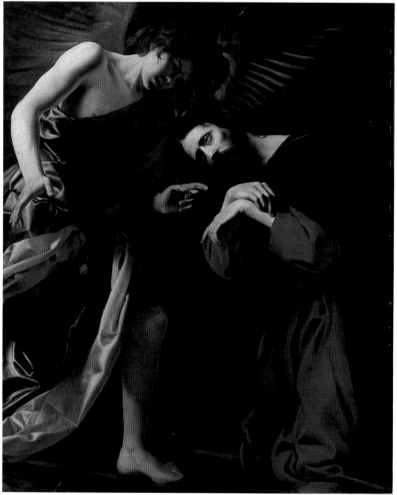

Giovanni Battista Caracciolo,
known as **Battistello**
Naples 1578 - Naples 1635
The Agony of Christ, c.1615,
monogrammed
Canvas, 148 x 124 cm
(Inv. no. F 17)
Archduke Leopold Wilhelm
collection 1659

A characteristic early work by this
important follower of Caravaggio
in Naples. Completely in the spirit
of the Counter-Reformation, the
painter combines narrative features
from the scene on the Mount of
Olives with static elements typical
of a devotional picture.

Guido Reni
Bologna 1575 - Bologna 1642
Baptism of Christ, before 1623
Canvas, 263.5 x 186.5 cm
(Inv. no. 222)
Duke of Buckingham's collection,
London. Acquired in Antwerp by
Archduke Leopold Wilhelm for
Emperor Ferdinand III's collection
in Prague in 1648; transferred to
Vienna between 1718 and 1733

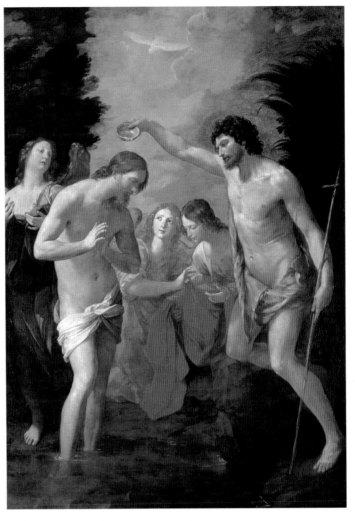

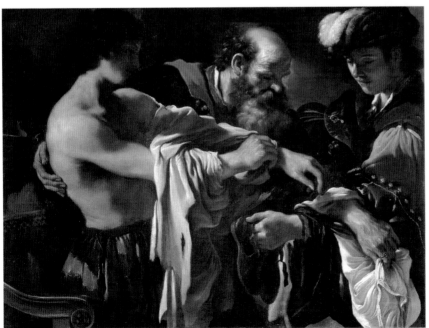

Guercino,
properly **Giovanni
Francesco Barbieri**
Cento 1591 - Bologna 1666
*The return of the prodigal
son*, c.1619
Canvas, 107 x 143.5 cm
(Inv. no. 253)
Painted for Cardinal Jacopo
Serra in Ferrara. In the
imperial gallery in Prague.
Transferred from Prague to
Vienna after 1718

Domenico Fetti
Rome *c.*1588/90 -
Venice 1623
Jacob's dream, *c.*1619
Poplar, 60.5 x 44.5 cm
(Inv. no. 3819)
Acquired in Antwerp
by Archduke Leopold
Wilhelm from the
Buckingham collection
for Emperor Ferdinand
III's collection in Prague
in 1648. In the imperial
gallery in Vienna since
1879

The observation of
'natural' truth learnt
from Caravaggio and
the completely 'spiritual'
way of painting which
seems to dissolve colour
in light combine here
to make a vision seem
convincing: Jacob on his
journey has fallen asleep
by the wayside with his
dog when the picture
of angels climbing up and
down a ladder appears to
him in a dream.

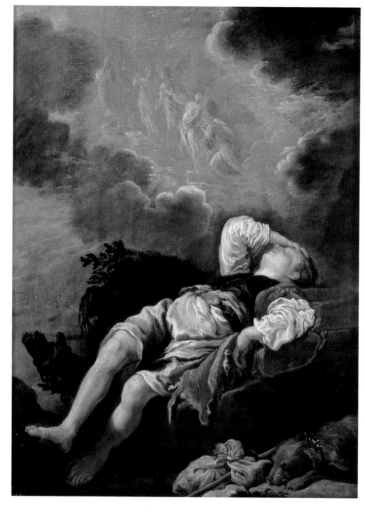

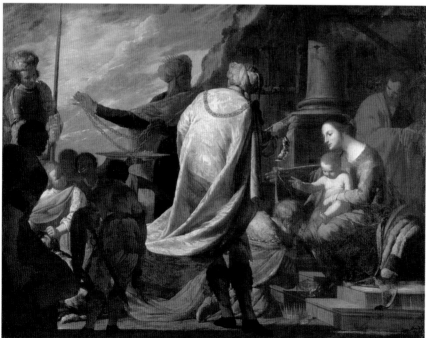

Bernardo Cavallino
Naples 1616 - Naples 1656
The adoration of the Magi,
*c.*1640
Canvas, 101.5 x 127 cm
(Inv. no. 6764)
Acquired 1928

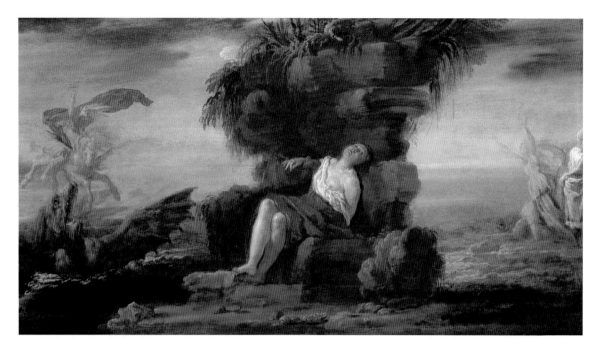

Domenico Fetti
Rome *c*.1588/90 - Venice 1623
Perseus freeing Andromeda, *c*.1622
Poplar, 40.5 x 72.5 cm (Inv. no. 7722)
Archduke Leopold Wilhelm collection 1659

One of a series of three sea mythologies possibly used to decorate a piece of furniture (*Hero and Leander* and *Polyphemus and Galatea* are depicted on the other two panels).

Girolamo Forabosco
Padua 1604/5 -
Padua 1679
Portrait of a Venetian lady,
c.1640/50
Canvas, 78 x 64 cm
(Inv. no. 3518)
Archduke Leopold
Wilhelm collection 1659

Bernardo Strozzi
Genoa 1581 -
Venice 1644
John the Baptist preaching,
late work
Canvas, 135 x 120 cm
(Inv. no. 256)
Archduke Leopold
Wilhelm collection 1659

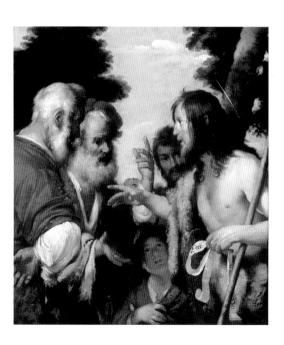

Luca Giordano
Naples 1634 - Naples 1705
The Archangel Michael driving the
rebellious angels into Hell, c.1665, signed
Canvas, 419 x 283 cm
(Inv. no. 350)
Came into the imperial collections
from the Minorite church (donation of
the Patalotti family), the Italian church
in Vienna, before 1796

Giordano's œuvre marks the end of
high Baroque decorative art and at
thsame time – particularly through
his interest in the colour problems –
ushers in Italian Rococo painting.
A palette with Venetian tones learnt
at first hand but also passed on to him
by his teacher Ribera, a Neapolitan
Ribera-like naturalism in the depiction
of the torments of hell, and the classical
compositional model provided by Guido
Reni lie behind this monumental
altarpiece by Giordano.

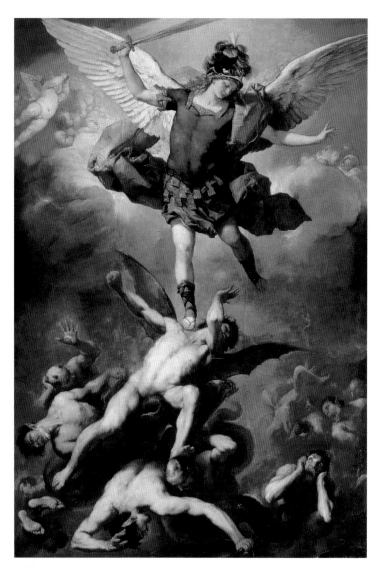

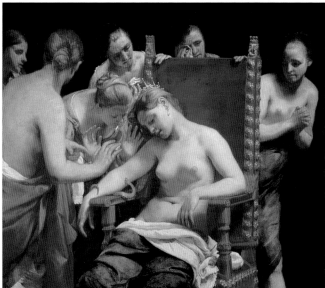

Guido Cagnacci
San Arcangelo di Romagna 1601- Vienna 1663
Suicide of Cleopatra, after 1659, signed
Canvas, 140 x 159.5 cm
(Inv. no. 260)
Archduke Leopold Wilhelm collection 1659
(addition)

Must originally have been planned as the single
figure of the dying Cleopatra. Composition
extended in the artist's own hand using six pieces
of canvas of varying size sewn on to the central
canvas.

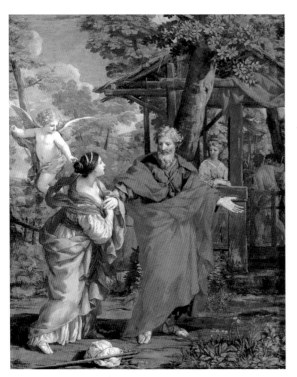

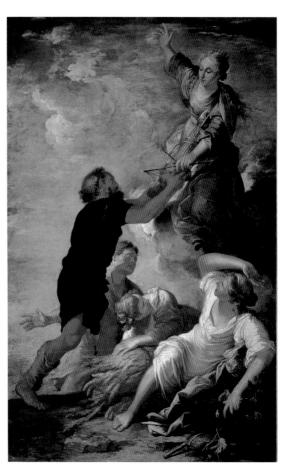

Pietro da Cortona, properly **Berrettini**
Cortona 1596 - Rome 1669
The return of Hagar, c. 1637
Canvas, 123.5 x 99 cm (Inv. no. 153)
From the Grand-Ducal collection in Florence;
exhibited there in the Tribuna of the Uffizi in
the eighteenth century. Acquired through
exchange in 1792

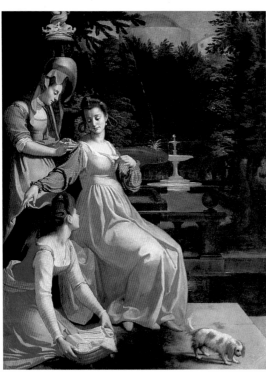

Jacopo da Empoli, properly **Chimenti**
Florence *c*.1551 - Florence 1640
Susanna bathing, 1600, signed and dated
Canvas, 229 x 172 cm (Inv. no. 1518)
Taken from Schloss Ambras near Innsbruck
to Vienna before 1781

Salvator Rosa
Arenella/Naples 1615 - Rome 1673
*Astraea leaving the earth, c.*1660/65
Canvas, 267.3 x 169.5 cm (Inv. no. 9856)
Acquired from a private owner in England
in 1988

In the Golden Age the celestial virgin Astraea,
goddess of justice, dwelt on earth. At the start
of the cruel Iron Age she was the last of the gods
to leave the earth. With her attributes (usually
scales and a lion) she was transferred to the skies as
the zodiac sign of Virgo. In Rosa's late picture the
departing Astraea is handing the farmers the *fasces*,
another old attribute of justice, and the scales.

47

Giuseppe Maria Crespi
Bologna 1665 - Bologna 1747
*Aeneas with the Sybil and
Charon, c.*1700
Canvas, 129 x 127 cm
(Inv. no. 306)
Painted for Prince Eugene
of Savoy, who had the picture
installed as an overdoor in the
state bedroom of his town
palace in Vienna; acquired for
the imperial collections in 1736

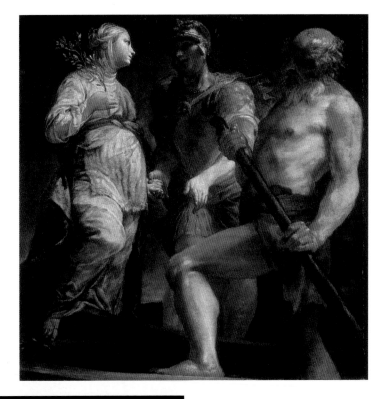

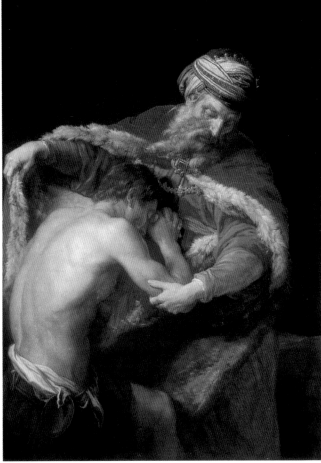

Pompeo Batoni
Lucca 1708 - Rome 1787
Return of the prodigal son,
dated 1773, signed
Canvas, 138 x 100.5 cm
(Inv. no. 148)
Acquired from the artist for
the imperial gallery in 1773

Giovanni Battista Tiepolo
Venice 1696 - Madrid 1770
The death of the consul Brutus in single
combat with Aruns, c.1728/3
Canvas, 383 x 182 cm (Inv. no. 6798)
Painted for the great hall of the Ca' Dolfin in Venice.
Acquired through Camillo Castiglione from the Miller
Aichholz collection in 1930

The cycle depicts events from Roman history after Livy.
The picture shows Brutus who fell in single combat with
Aruns, the son of the last deposed Etruscan king, in the
Romans' battles against the Etruscans, a duel that also
cost Aruns his life.

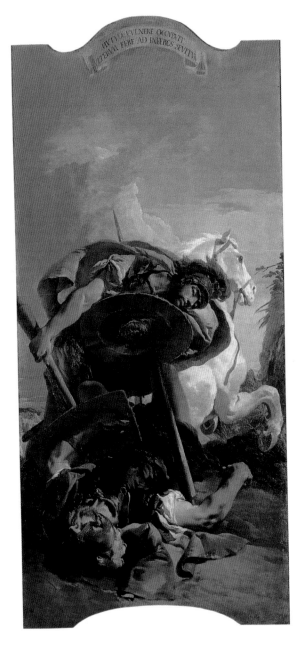

Francesco Solimena
Canale di Serino/Avellino 1657 - Barra/Naples 1747
Descent from the Cross, c.1730/31
Canvas, 398 x 223 cm (Inv. no. 3507)
Commissioned by Prince Eugene of Savoy for the chapel
of his hunting lodge, Schlosshof in the Marchfeld.
Acquired for the imperial collections in 1752

During the period of Austrian sovereignty over Naples
(1707-34) the most important artists in the city worked
for the Austrian high nobility and the emperor's court.
Solimena, the head of the Neapolitan school, also furnished
the chapel of the Belvedere, Eugene's summer palace, with
an altarpiece, still *in situ*, and a ceiling painting.

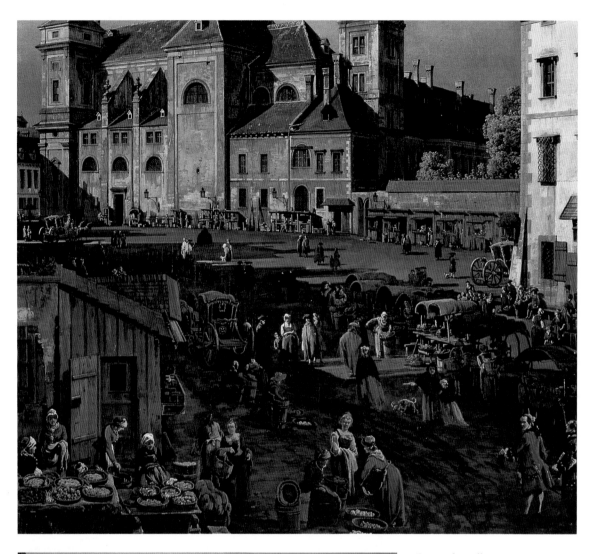

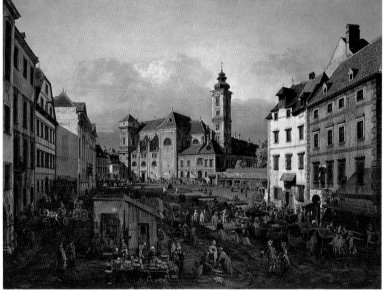

Bernardo Bellotto,
known as **Canaletto**
Venice 1721 - Warsaw 1780
*The Freyung in Vienna from
the south-east*, c.1760
Canvas, 116 x 152 cm
(Inv. no. 1654)
In imperial possession since
it was created

At the centre in the background
the Schottenkirche, and on the
left in the middle distance the
Palais Harrach by Domenico
Martinelli.

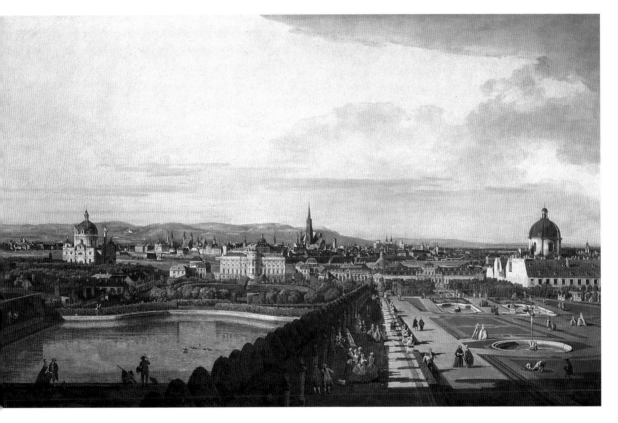

Bernardo Bellotto, known as **Canaletto**
Venice 1721 - Warsaw 1780
Vienna, seen from the Belvedere Palace, c.1760
Canvas, 136 x 214 cm (Inv. no. 1669)
In imperial possession since it was created

The view of Vienna, seen from Prince Eugene's Schloss Belvedere in the south of the city which was by then already in imperial possession, is framed to the left and right by the domed silhouettes of the Karlskirche and the church of the Salesian nuns. To the right of the Karlskirche we see the Palais Schwarzenberg, and in the middle the pointed tower of St Stephen's cathedral towering above the city encircled by its walls. In the background lie the Kahlenberg and Leopoldsberg hills.

Early Netherlandish and Flemish Painting

In the collection of North European painting there is a clear weighting towards the art of the southern Netherlands from the fifteenth to the seventeenth century. Archduke Leopold Wilhelm thought he owned several pictures by one of the founders of Early Netherlandish panel painting, Jan van Eyck who worked in Bruges and Ghent, 'who first invented oil paint' (as the 1659 inventory claimed). There is general agreement today that the sitter in the portrait of 'Cardinal von Santa Croce' – as it is described in Leopold Wilhelm's inventory – is the papal legate, Cardinal Niccolò Albergati. Although all the visible traces life has left on the face of the old man are depicted in minute detail, the overall form can be seen large and clear; the new sense of reality does not get lost in detail.

Rogier van der Weyden was less a coolly objective observer of the world than a depictor of the drama of religious events. His *Crucifixion triptych* is one of the masterpieces of the so-called 'town painter' of Brussels. In the intensity of the expression of feeling, as well as in the sometimes ornamental movement of the drapery and figures, Rogier is more strongly attached to the late Gothic tradition than van Eyck. Yet his way of painting is also deeply imbued with reality, and his colours too have an extraordinary luminosity as a result of the technique of mixing resin, oil and tempera and applying it in layers of glaze.

It is interesting to observe the gradual change in style in the relationship of the Early Netherlandish masters towards Italy, the centre of the new humanist and idealistic art. Apart from a few marginal details the fact that Rogier van der Weyden undertook a pilgrimage to Italy in 1450 left no traces either on his painting or on Italy. On the other hand, while Hugo van der Goes, the melancholic master who worked in Ghent, never went to Italy himself, the huge altar with the *Adoration of the shepherds* which he created in 1475-6 for Tommaso Portinari, the head of the Medicis' agency in Bruges, now in the Uffizi in Florence, made a deep impression on Italian painters. As well as the luminous colouring it was first and foremost his ability to make visible individual psychological experience – in Italy they would talk about the 'affects' – and thus coax the pious viewer into reconstructing and contemplating the event. This can also be seen impressively in his early work, the small two-part domestic altar with the *Fall*; typologically the representation of *Salvation* through the sacrificial death of Christ is related to this.

Netherlandish painting was not completely permeated by the Italian Renaissance until a generation later, with Jan Gossaert, Bernaert van Orley, Joos

Peter Paul Rubens
Siegen 1577-
Antwerp 1640
*Vincenzo (II) Gonzaga, Prince of Mantua, c.*1604/5
Canvas, 67 x 51.5 cm
(Inv. no. 6084)
Acquired 1908

Fragment of the left-hand donor group from the high altar picture from the Jesuit church in Mantua cut up by occupying French troops (1801), depicting the *Holy Trinity worshipped by the Gonzaga family*. The broad impasto brushwork – applied so that the picture could be viewed from the distance – and the colouring point stylistically to Venice, and it is hardly surprising that the fragment was attributed to Veronese before its origin was known.

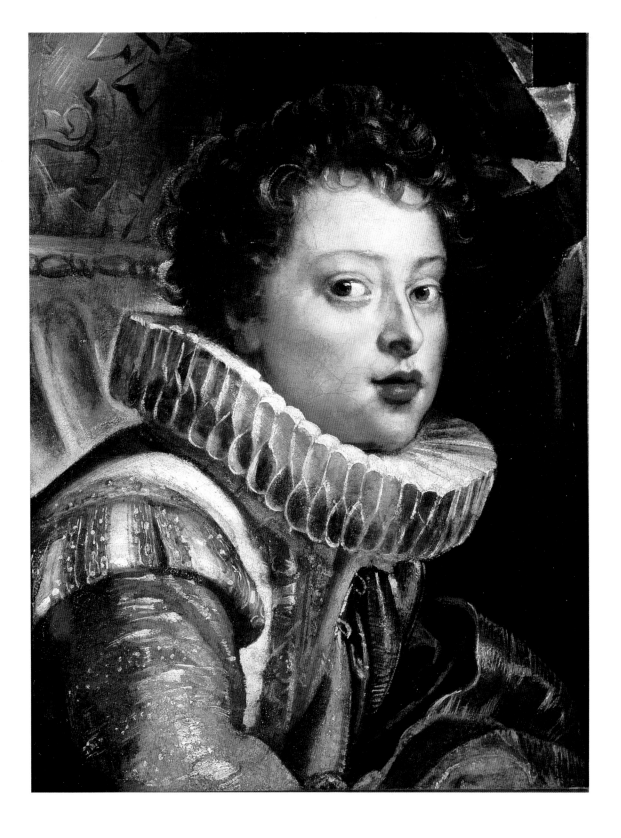

van Cleve, Jan van Scorel and in particular Maerten van Heemskerck, though it never abjured the indigenous ideals of the colourful presence and precision in conveying the 'superficial' details. All these painters spent a fairly long time in Italy. Gossaert, Orley, Cleve and Scorel were already influenced by the art of Leonardo da Vinci or Raphael and his school, and they also played a considerable role in disseminating the new style in the north.

Painters like Geertgen tot sint Jans, the individualist Hieronymus Bosch and Joachim Patinier, the true creator of Netherlandish landscape art so much admired by Dürer, most of them from the northern Netherlands, were obviously barely influenced by Italian art. Landscape was already playing an important role, and in seventeenth-century Dutch painting in particular it was to be of supreme artistic importance. The masterpiece of Geertgen tot sint Jans points to another speciality of seventeenth-century Dutch painting. In the picture narrative of the *Fate of the earthly remains of St John the Baptist* the group portraits play a particularly interesting role; the 'democratic' line-up shows a group of like-minded, generally similarly dressed people depicted engaged in some activity, but their attention is divided in a peculiar way, concentrated neither on one another nor on the activity which has brought them together. All this anticipates the Dutch group portraits of the sixteenth and seventeenth centuries.

The Bruegel collection of the Kunsthistorisches Museum, comprising a quarter of the surviving works of Pieter Bruegel the Elder, is one of the main attractions of the Vienna Paintings Collection. The artist's work as a painter, extending over a period of just twelve years, can here be followed step by step. Bruegel is justly regarded as the perfector of Old Netherlandish painting and its finest exponent. In Bruegel the descriptive realism which had dominated the painting of the Netherlands in varying degrees since Jan van Eyck, coming even more strongly to grips with reality, leads to a recognition of the world in a higher sense – an interpretation of the world comprehending nature and humanity in equal degrees – without necessarily assuming a time-specific contemporary viewpoint towards political or specifically moral circumstances.

Bruegel's documented activity as a painter in Antwerp and Brussels did not begin until 1557 after his return from an extensive journey to Italy and his employment with the publishing firm of Hieronymus Cock to which he supplied drawings.

In *The Tower of Babel* he has certainly already dispensed with the scattered distribution of the figures on a tipped-up ground, familiar to us from the 'early' pictures, but the high viewpoint of the observer looking towards the distance of a landscape, with the huge bulk of the tower rising in the middle ground, is still conceived in a similar way to the early period. In 1565/6 Bruegel created what must be his most all-embracing work, the six-part cycle of the *Times of the year*, and three of the paintings are still in Vienna. In these pictures, which must originally have been conceived for some sort of frieze arrangement, Bruegel accomplishes his idea of an earthly cosmos, with the events of nature occurring cyclically in the course of the year while human beings occupy their place in the cosmos, with their activities corresponding to the seasons. In the final years of his short career as a painter Bruegel's style shifted towards the monumental, with large figures. While he sometimes uses Mannerist compositional schemes like the diagonals leading at an angle into the picture area, his art is nonetheless completely individual, always imbued with sharply observed reality, in line with everyday usage. The compact, seemingly naive style of the figures can best be described as being 'archaic'. Thus not only were his pictures

Jan van Eyck
Maaseyck *c.*1390 - Bruges 1441
*Cardinal Niccolò Albergati, c.*1435
Oak, 34.1 x 27.3 cm (Inv. no. 975)
Bought from the collection of the Antwerp art
dealer Peeter Stevens by Archduke Leopold
Wilhelm in 1648

In spite of other identifications that of Niccolò
Albergati, cardinal of Santa Croce in Gerusalemme,
superior general of the Carthusian order and bishop
of Bologna, is still the most convincing. In 1431
Albergati went as a papal legate to the courts of
France, England and Burgundy with the mission of
ending the Hundred Years' War between England
and France by instituting peace negotiations. Jan
van Eyck drew him from life at that time (Dresden,
Kupferstichkabinett) and afterwards painted this
picture.

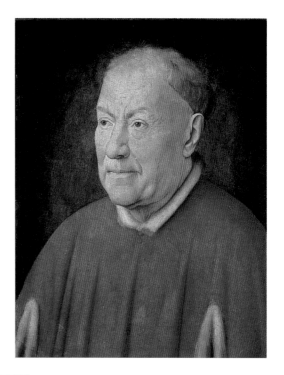

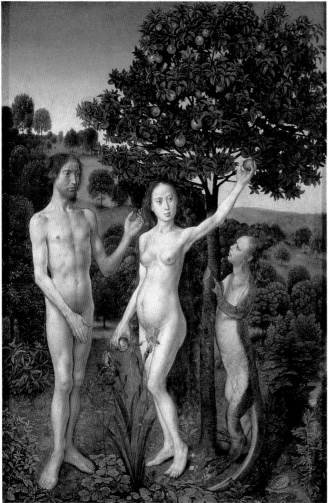

Hugo van der Goes
Ghent 1430/40 - Brussels 1482
The fall, from a diptych with *The fall of man
and salvation (Lamentation of Christ)*, 1479
Oak, 32.3 x 21.9 cm (Inv. no. 5822)
Perhaps bought from the artist by (the later)
Emperor Maximilian I. In Archduke Leopold
Wilhelm collection 1659 as a picture by van Eyck

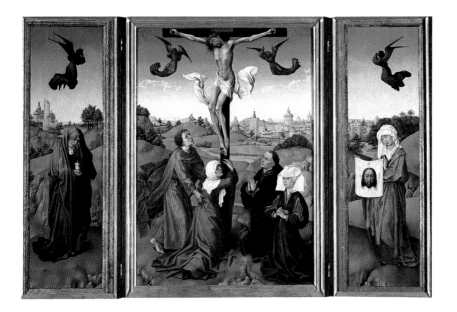

Rogier van der Weyden
Tournai 1399/1400 -
Brussels 1464
*Crucifixion triptych with
SS Mary Magdalene and
Veronica* (wings), *Mary
and John and the unknown
donors, c.1440*
Oak, central panel
96 x 69 cm,
wings 101 x 35 cm
(Inv. no. 901)
Archduke Leopold
Wilhelm collection 1659

a substitute for the world to Emperor Rudolf in his loneliness, probably because of the power with which they were formulated and their trenchant grasp on reality, but for us too they epitomize depiction from daily life, before that art declined into genre painting.

Almost all the paintings from the Rudolphine artistic circle, named after the emperor, come from Rudolf II's Kunstkammer in Prague. The many surviving works of these (frequently Netherlandish) painters, Bartholomäus Spranger, Joseph Heintz, Hans von Aachen or Dirck de Quade van Ravesteyn, reflect the emperor's refined taste and today form a characteristic section of the Paintings Collection. Great technical virtuosity, extreme formalism, morbid sensualism in the surface treatment demanding close-up viewing, the sometimes complicated allegorical and mythological subject matter (the introverted emperor commissioning the works had a special predilection for its erotic connotations): all these are hallmarks of the international Prague court style, which was nonetheless influenced by the Netherlands.

The Rubens collection at the Kunsthistorisches Museum is one of the most important in the world, along with those at the Prado, the Louvre and the Alte Pinakothek in Munich. As in Madrid it was the Habsburgs who encouraged Rubens and collected his pictures. Particularly typical examples of all aspects of his art can be admired in Vienna in a manner rarely possible elsewhere: the large Counter-Reformation altarpiece, sometimes along with the preparatory models, the devotional picture intended for private religious practice, the portrait (including historicist portraits, adaptations of older ones and portraits enhanced to mythology), landscape, mythology and allegory, including political allegory, a means of expression very characteristic of Rubens the diplomat.

The only 'Italian' work by Rubens in the Paintings Collection is the fragment of the originally huge altar painting from the Jesuit church in Mantua with the *Holy Trinity worshipped by Vincenzo Gonzaga and his family*, which was not acquired until 1908. After his return from Italy, Rubens was, from 1609 on, very widely employed in his native town of Antwerp as a court painter for the Spanish Governor, Archduke Albrecht, a brother of Emperor Rudolf II, and his wife, the Infanta Isabella Clara Eugenia, the favourite daughter of Philip II of Spain. He became the favourite

painter of the Antwerp townspeople and executed paintings for the major religious orders, especially the Jesuits, as well as for foreign princes.

Rubens had returned home at exactly the right time. The once rich city of Antwerp on the Scheldt estuary had been very adversely affected by Spain's long war against the northern, Protestant part of the Netherlands which had severed links with its mother country. The cessation of hostilities agreed in 1609 meant economic prosperity for Antwerp, and for the part of the Netherlands that had remained Spanish. In order to satisfy the growing demand for his pictures Rubens surrounded himself with assistants – including Jan Bruegel the Elder, Anthonis van Dyck (Anthony Van Dyck) and Jacob Jordaens – in a studio workshop based on division of labour and run on a sound economic footing.

Only three altar paintings, depicting the *Assumption of the Virgin*, *The miracle of St Ignatius* and *The miracle of St Francis Xavier*, have been preserved from Rubens's most ambitious project in the second decade of the seventeenth century, the pictorial furnishing of the Jesuit church in Antwerp with thirty-nine ceiling paintings and three gigantic altarpieces, and these are in Vienna; the preparatory *modelli* for the paintings are also in the collection. Rubens's intellectual programme compels our admiration, combining the exhortatory mission of Counter-Reformation religious painting with an artistic concept in which ideality and illusionism coincide with quite tangible reality.

In the large altar pictures as well as in allegories such as the *Four great rivers of Antiquity* the emotionally charged figures of a giant human race are impressive. In Rubens's own words, the world of Christian salvation and that of resurrected Antiquity as an ideal creation already founded in the terrestrial were here contrasted with the newer human being who had degenerated in centuries of senile debility, caused by misadventures and as a result of the spread of vices.

Rubens's landscapes are particularly beautifully represented by the *Stormy landscape with Philemon and Baucis*; there are several additional panels in which the landscape is transformed to explicit mythology.

The first supreme achievement of Rubens's late period, starting biographically with his gradual withdrawal from public diplomatic functions and his second marriage to Hélène Fourment, 37 years his junior, is the *Ildefonso altar*, a miracle of painting. Rubens here employs the tried and trusted form of the three-part winged altar, used in Old Netherlandish painting. With extreme painterly freedom, sometimes with an open, pastose, confidently applied brushstroke, sometimes with the paint applied in translucent glazes, a colourful vision is created from red, golden and a few cool tones, combining the merits of Rubens's so different prototypes in a unique way: the coalescently hazy, atmospheric colours of the sixteenth-century Venetians and the enamel-like, precious, close-up corporeality of the Early Netherlandish.

Rubens's late self-portrait when he was about 62 years old is the only one in which he used the formal three-quarter-length portrait. It is also official in the attributes, clothes and demeanour of the painter prince; he depicts himself here in the grand style as a courtier. However, beyond any official pose his features reveal a certain sceptical aloofness with an alert, appraising watchfulness.

None of the Flemish painters of the seventeenth century could escape the overpowering influence of Rubens. Jacob Jordaens and Anthony Van Dyck were the two who continued to develop in the most independent way. Jordaens's unmistakable way of directly reproducing an often burlesque, vivid reality should not conceal the fact that he composed his pictures very strictly, full of life as they

are, with the wealth of movement virtually spilling out of the pictural space. Thus in looking at the *Feast of the bean king* from Jordaens's late period the viewer can immediately make sense of what appears to be a jumble.

In contrast to Jordaens, Van Dyck (subsequently Sir Anthony Van Dyck), who was certainly Rubens's most important pupil and assistant, left a mark which indicates internalization in the sense of a 'psychological' interpretation of a spiritual drama, often in direct emulation of Rubens. In the religious and mythological history paintings and in the portraits, Van Dyck's figures – their restless insistence, their desires, their devotion, their passions or whatever the painter instils in them – abandon themselves sometimes in an almost shameless, ecstatic manner. The painterly form of the younger artist does not have its origins in the body, perceived from within, from its core, and shaped to perfection like a sculpture, rather it develops as it were in parallel to the picture plane, is expressed in the line. The artistically crucial fields of expression come to the surface, to the physical periphery, into the hands, the hair, the contour of the moving drapery. Hence the tangled, 'tousled' brushstroke with the roughly applied paint, which in a restless, fidgety, often coarse way is concerned not with rounding the body but with direct, deliberate expressiveness. This can be observed particularly in the early period when Van Dyck was still working closely with Rubens, but later too, after his return from the Italian journey that was intended to 'tame' him.

Later on, when the successful court painter left a lasting mark on the picture of the aristocrat in his unquestioning aloofness, the rapid, fluent, elegantly virtuoso brushstroke was able to convey the colours and surface attractiveness of the silks, brocades, armour and skin. Here again the brushstroke was used for expression: Van Dyck conveys sitters as people of standing in the required elegance and dignity, but over and above this an emotional tension can be detected between the elegant display and the persons in themselves. Sometimes this is perceptible only in an often merely latent movement, sometimes it is more clearly staged, from the barest suggestion of nervous irritation to the expression of downright impertinent arrogance in many of the late portraits of the English aristocracy.

Van Dyck's extreme sensitivity, his inner unrest, which in his life can be perceived in his exceptional precocity and later in the unsettled peregrinations motivated by ambition taking him from one country or court of Europe to another, his capacity to suggest spiritual connections between people, can verge on the sentimental in his painting, or at the other extreme it can verge on the ecstatic. In his religious painting he was able – as for example in the *Mystic marriage of the Blessed Hermann Joseph* – to strike a note of resolved gentleness and charm which had not hitherto been heard in the Counter-Reformation. In pictures such as *Samson and Delilah* this sensitivity releases an urgency, even almost – in the eye contact – an intrusiveness in the protagonists. As in this painting, the expression of psychological instability may also lead to what virtually amounts to a structural lack of equilibrium in the composition: clearly distinct from Rubens's "'stoical' control of the 'equivalences'" (Burckhardt).

Geertgen tot sint Jans
Leiden(?) 1460/65 –
Haarlem after 1490
*The fate of the earthly
remains of St John the
Baptist*, after 1484
Oak, 172 x 139 cm
(Inv. no. 993)
Outer side of the right
wing of the high altar
from the church of the
Knights of St John in
Haarlem; taken to
Utrecht after the
destruction of the altar
in 1573. Presented to
King Charles I of
England by the States
General in 1636, and
by him to the Marquess
of Hamilton. Archduke
Leopold Wilhelm
collection 1659

The commission was
prompted by the relics
being handed over by
the Turks in 1484.
The inside right wing
with the *Lamentation
of Christ* is also in the
Kunsthistorisches
Museum. The story of
the remains of St John
the Baptist is recounted
in the complicated
structure of a 'continuous
narrative' in which open
landscape and townscape
are combined with the
grotesque features of the
picturesque, but pagan,
foreground. The account
goes from the burial of
the remains by Herod's
wife by way of the
exhumation and
cremation of the bones
on the orders of Emperor
Julian the Apostate to
the rediscovery of the
unburnt remains by the
Knights of St John.

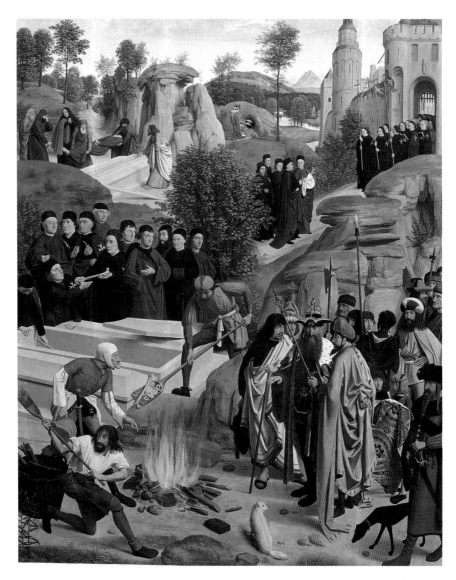

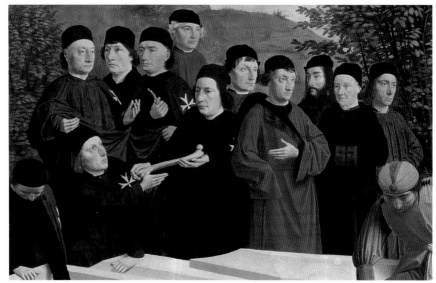

Hieronymus Bosch
'S-Hertogenbosch *c*.1450 - 'S-Hertogenbosch 1516
Christ carrying the Cross, *c*.1480
Oak, 57 x 32 cm (Inv. no. 6429)
Acquired 1923

Left wing of a small Crucifixion altar. Below the carrying
of the Cross are scenes in a 'modern' setting with the
confession of the good thief and the torment of the evil
one. On the reverse side in grisaille there is a child with
a toy windmill and a push-cart whose innocence and lack
of understanding form a contrast to the front.

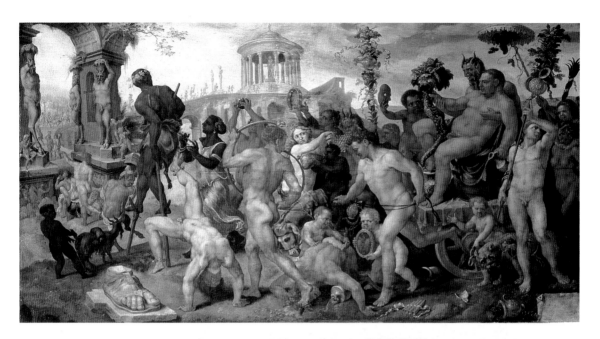

Maerten van Heemskerck
Heemskerck 1498 - Haarlem 1574
Triumph of Bacchus, *c*.1536/7, signed
Oak, 56.3 x 106.5 cm (Inv. no. 990)
According to van Mander in the collection of P. Kempenaer and M. Wijntgens
in Middelburg *c*.1600, Archduke Leopold Wilhelm collection 1659

The triumphal return of Bacchus from India to Greece is depicted with sometimes crude
decorative details. Created shortly after Heemskerck's visit to Rome, the picture is full of
reminiscences of antique and Italian provenance which document his compilatory manner
of working. The concealed moralistic content of the picture warning against drunkenness,
sexual excess, foolishness and arrogance, should not be overlooked.

Joachim Patinier
Bouvignes (?) c.1483 - Antwerp 1524
Baptism of Christ, c.1515, signed
Oak, 59.7 x 76.3 cm (Inv. no. 981)
Archduke Leopold Wilhelm collection 1659

Bernaert van Orley
Brussels 1488 - Brussels 1541
Altar to SS Thomas and Matthias,
c.1512/15, signed
Oak, 140 x 180 cm (Inv. no. 992)
Acquired in 1809

Formerly the central panel of a
winged altar donated by the Guild
of Masons and Carpenters for
Notre Dame du Sablon in Brussels;
the wings belonging to it are in the
Musées Royaux des Beaux Arts,
Brussels. On the left St Thomas
is being stabbed by the sword of a
heathen Indian priest, and in the
background the saint is walking over
glowing coals and is being pushed
into an oven. On the right the choice
of Matthias as an apostle, in the
background his sermon, the handing
over of the goblet of poison, and the
death of the antagonists. Note the
'Italian' architectural ornamentation.

Jan Gossaert,
known as **Mabuse**
Maubeuge *c.*1478-
Middelburg 1532
St Luke painting the Virgin,
*c.*1520
Oak, 109.5 x 82 cm
(Inv. no. 894)
Archduke Leopold
Wilhelm collection 1659

Gossaert's encounter with
antique buildings and the
classical architectural
settings and relief work
used in contemporary
Italian painting which he
had seen in Rome had its
effect on the formation of
the architectural staffage
and ornamentation in
these Netherlandish
pictures. Gossaert has
transformed the legend
of the Virgin sitting for
a portrait by St Luke, a
favourite theme in northern
art, into a visionary
apparition of the Virgin
to the evangelist and
patron saint of painters.

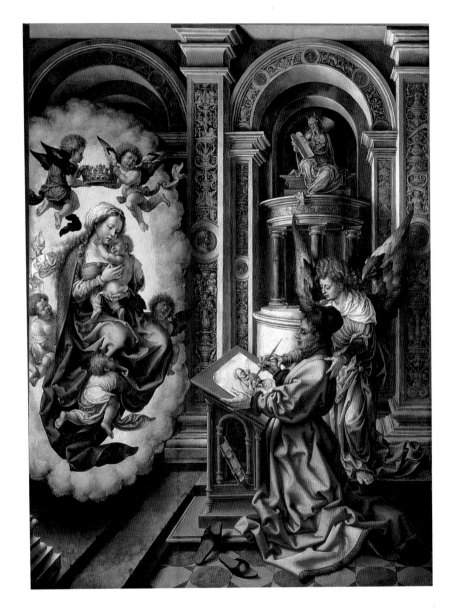

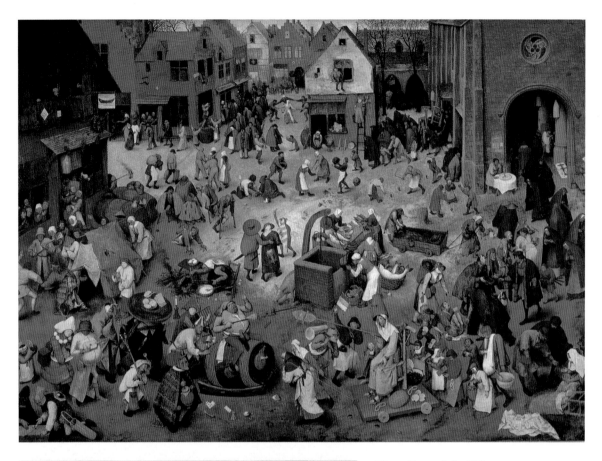

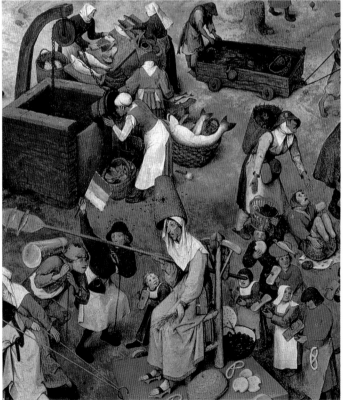

Pieter Bruegel the Elder
Breda(?) 1525/30 - Brussels 1569
The fight between Carnival and Lent, 1559,
signed and dated
Oak, 118 x 164.5 cm (Inv. no. 1016)
Presumably Emperor Rudolf II's
collection, transferred from the Vienna
treasury to the gallery in 1748

The customs and spectacles of the two
opposite yet consecutive periods of the
calendar Carnival and Lent are played out
in a town setting between the symbolic sites
of tavern and church as in a tournament
(it was in fact enacted as a popular play),
depicted with a sometimes ironic accuracy
characterizing the 'human menagerie'.

**Pieter Bruegel
the Elder**
Breda(?) 1525/30 -
Brussels 1569
The Tower of Babel, 1563,
signed and dated
Oak, 114 x 155 cm
(Inv. no. 1026)
Emperor Rudolf II's
collection, Archduke
Leopold Wilhelm
collection 1659

The allegory turned into
a picture is inscrutably
yet plainly an ironic
commentary on the
human hubris which
brought on God's
punishment. Mutually
incompatible architectural
concepts – the spiralling
ramps climbing up the
outside and the storeys
internally, the rectangular
construction of the
verticals on the ascending
ramps dictated by
structural considerations
which must cause the
tower to lean – demonstrate
the defective planning of
the enterprise from the
outset.

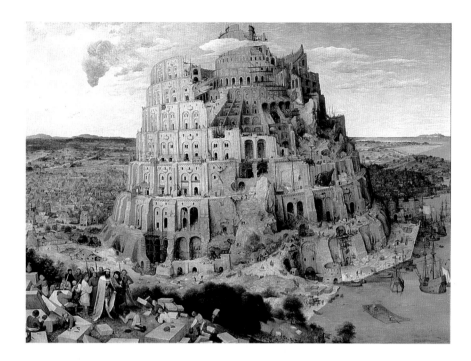

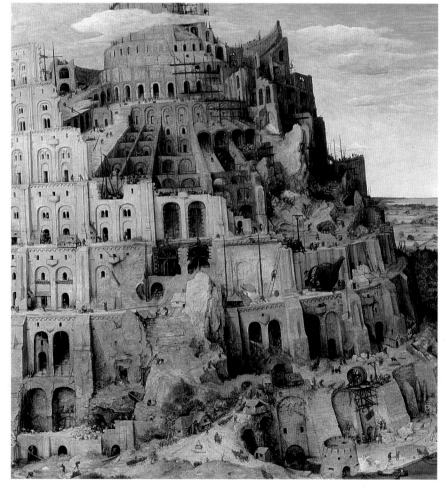

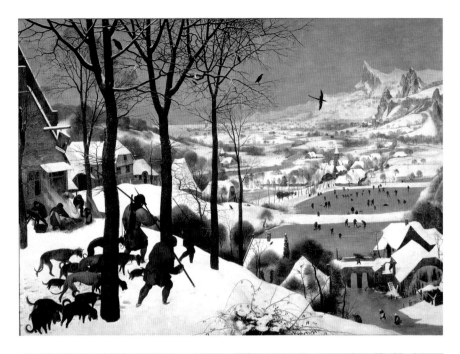

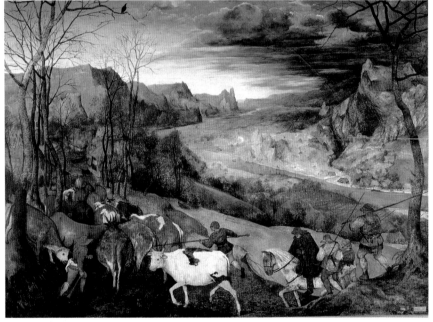

**Pieter Bruegel
the Elder**
Breda (?) 1525/30 -
Brussels 1569
*Hunters in the snow
(winter)*, 1565, signed
and dated
Oak, 117 x 162 cm
(Inv. no. 1838)
The *Times of the year*
series was at the home
of Nicolaes Jongelinck
in Antwerp in 1566; he
guaranteed the debts of
a third party to the city
of Antwerp with his
property; after the
pictures had passed to
Antwerp as a result of
the bond, in 1594 the
city presented the
six-part series to the
(Spanish) Governor,
Archduke Ernst, the
brother of Emperor
Rudolf II into whose
possession the pictures
then passed; Archduke
Leopold Wilhelm
collection 1659

Of the series *The gloomy
day* ('Early spring') and
*Return of the herd
(autumn)* are also in the
Paintings Collection of
the Kunsthistorisches
Museum, while *The corn
harvest* ('Early autumn')
is in the Metropolitan
Museum in New York,
and *Haymaking* ('Early
summer') in the Lobkowitz
collection in Prague.

Pieter Bruegel the Elder
Breda(?) 1525/30 - Brussels 1569
Return of the herd (autumn), 1565, signed and dated
Oak, 117 x 159 cm (Inv. no. 1018)

While Bruegel is still following the tradition of depicting the months, taking it to
its peak, his pictures have abandoned the virtually illustrative character. Although the
landscape is not a topographical reproduction, being composed of common constitutive
elements such as hills, valleys, sea, rivers and towns, it nonetheless has supreme truth in
conveying experienced space and experienced time, with all its moods.

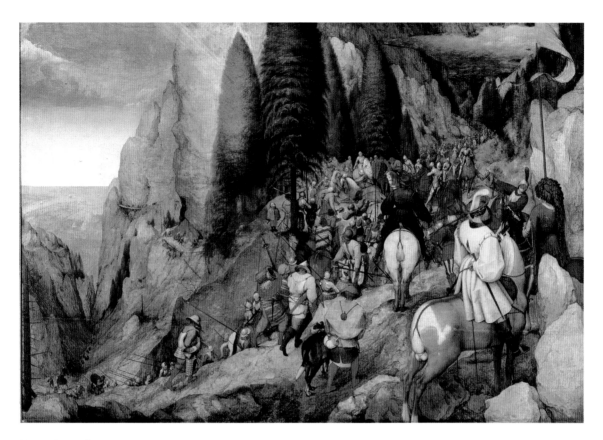

**Pieter Bruegel
the Elder**
Breda(?) 1525/30 -
Brussels 1569
The conversion of St. Paul,
1567, signed and dated
Oak, 108 x 156 cm
(Inv. no. 3690)
Acquired by Archduke
Ernst in Brussels in 1594;
Emperor Rudolf II's
collection, brought from
Prague to Vienna in 1876

Scholars keep trying to
find allegories of the
Bible story over and
above the literal narrative.

Jan Brueghel the Elder
Brussels 1568 -
Antwerp 1625
Flowers in a blue vase,
*c.*1608
Oak, 66 x 50.5 cm
(Inv. no. 558)
Moved from the Secular
Treasury to the imperial
gallery in 1748

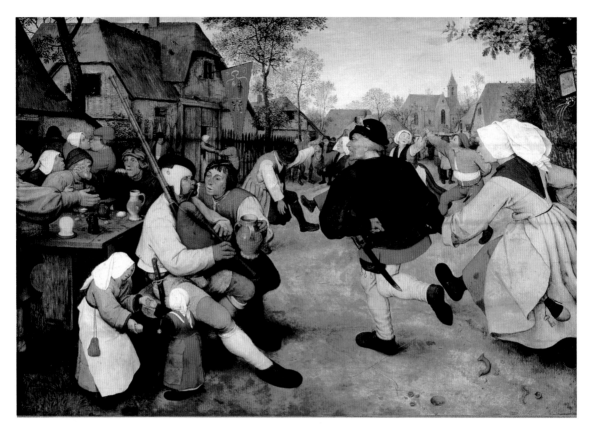

**Pieter Bruegel
the Elder**
Breda(?) 1525/30 -
Brussels 1569
*Peasant dance, c.*1568,
signed
Oak, 114 x 164 cm
(Inv. no. 1059)
Emperor Rudolf II's
collection (?), in
imperial collections
in Vienna 1612/18,
moved from Treasury
to gallery in 1748

Giuseppe Arcimboldo
Milan 1527 - Milan 1593
Water, 1566
Limewood, 66.5 x 50.5 cm
(Inv. no. 1586)
Painted for Emperor
Maximilian II, then in the
Kunstkammer of Rudolf II

As a court painter to the
Habsburgs from 1562 to 1587
the Lombard artist Arcimboldo
created two cycles with
allegorical depictions of the
seasons and the elements in
1563 and 1566 respectively.
In them characteristic objects
from the subject matter in
question are assembled into
heads verging on portrait
likenesses.

Pieter Bruegel the Elder
Breda (?) 1525/30 - Brussels 1569
Peasant wedding, c.1568
Oak, 114 x 164 cm
(Inv. no. 1027)
Acquired by Archduke Ernst in Brussels in
1594; Emperor Rudolf II's collection (?),
Archduke Leopold Wilhelm collection 1659

A rich peasant wedding in accordance with
Netherlandish or Flemish sixteenth-century
customs. The bride is sitting under the paper
bride's crown, the notary required to draw up
the marriage contract is in the high armchair,
above at the table is the landowner dressed in
Spanish style. The bridegroom is missing, as
he was not united with the bride until the
evening of the wedding.

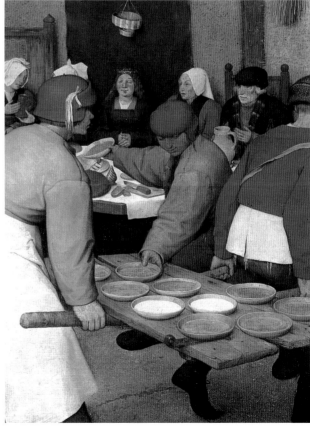

Bartholomäus Spranger
Antwerp 1546 -
Prague 1611
*Venus and Adonis, c.*1597
Canvas, 163 x 104.3 cm
(Inv. no. 2526)
From the Kunstkammer
of Rudolf II, in the
imperial gallery in Vienna
in 1781

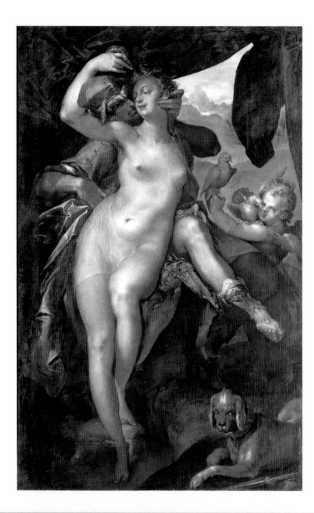

**Dirck de Quade van
Ravesteyn**
1589/99 and 1602/8
in Prague
*Venus in repose, c.*1608
Oak, 80 x 152 cm
(Inv. no. 1104)
Presumably from the
Kunstkammer of Rudolf
II, in the imperial gallery
in Vienna in 1781

Probably a courtesan
at the court of Rudolf II
in Prague is depicted
here with mythological
trimmings, alluding to
sixteenth-century
Venetian models.
The convincing new
ascription to Ravesteyn
has superseded its
traditional attribution
to Joseph Heinz.

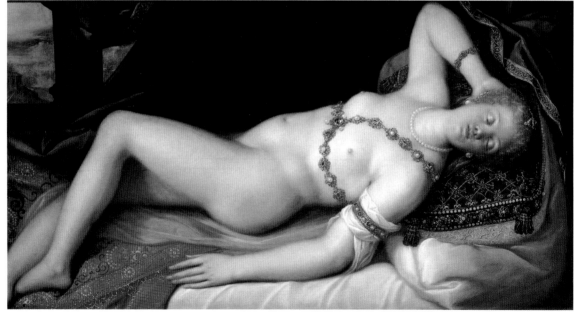

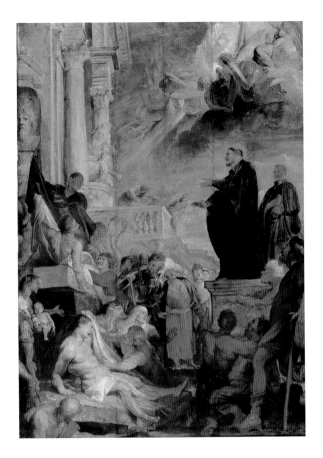

Peter Paul Rubens
Siegen 1577 - Antwerp 1640
Miracles of St Francis Xavier, c.1616/17
Oak, 104.5 x 72.5 cm (Inv. no. 530)
Purchased from the Jesuit order's Professhaus
(convent) in Antwerp in 1776

Modello for the former high altar picture of the Jesuit
church in Antwerp which must have been finished in
1618, also in the Kunsthistorisches Museum. Protected
by the personification of Faith, Francis Xavier, one of
the founders of the Jesuit order, is presented as a
missionary in Asia: preaching to the heathen, awakening
the dead, healing the lame and the blind and toppling
idols – in synchronization the repertory of every person
striving to achieve saintliness is introduced.

Peter Paul Rubens
Siegen 1577-
Antwerp 1640
*Stormy landscape with
Philemon and Baucis*,
c.1620/25
Oak, 146 x 208.5 cm
(Inv. no. 690)
Mentioned in the
inventory of Rubens's
estate in 1640, Archduke
Leopold Wilhelm
collection 1659

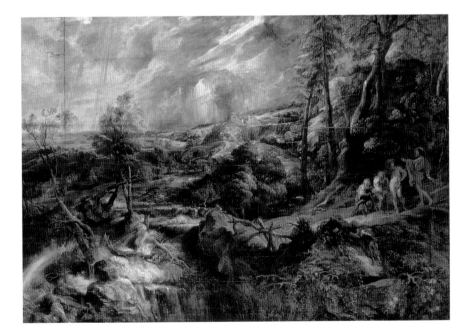

The picture is not a
pure landscape: working
on it at a later stage
(which can be recognized
because of pieces stuck
on to the original panel)
Rubens added Philemon
and Baucis, thus raising
the landscape to a
mythological level. The
true protagonist in the
drama is still 'nature
depicted going about its
most powerful activity,
and in its greatest human
aspect, that of destruction'
(K. Demus).

71

Peter Paul Rubens
Siegen 1577-
Antwerp 1640
*The four great rivers of
Antiquity, c.1615*
Canvas, 208 x 283 cm
(Inv. no. 526)
In the imperial collections
in Prague in 1685, in
Vienna before 1733

Contrary to the traditional
title of this picture, *The
four continents*, more recent
research makes it seem
probable that it is not the
female personifications of
the four continents then
known, Africa, Asia,
Europe and America,
with their 'male' main
rivers that are being
depicted, but the four
rivers documented in the
literature of Antiquity and
associated with the four
rivers of paradise: the Nile
(front left), Tigris (front
right), Euphrates (back left)
and Ganges (back right),
accompanied by their
attendant naiads.

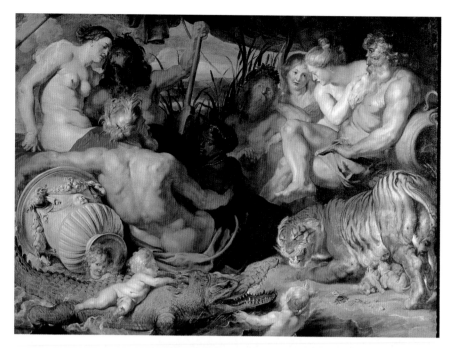

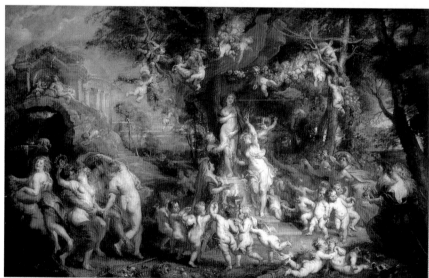

Peter Paul Rubens
Siegen 1577 - Antwerp 1640
Feast of Venus, c.1635/7
Canvas, 217 x 350 cm (Inv. no. 684)
In the imperial collections in Prague in 1685, in Vienna in 1721

This picture conjures up the far horizon of humanist culture, and
Rubens's ability completely to transform a multiplicity of external
inspirations from literature and the visual arts by means of 'letting
his imagination roam freely' (J. Burckhardt). The *Feast of Venus* is
linked to Titian's picture of the *Gods of love* which Rubens copied.
He paraphrases Titian but develops his meaning into an extremely
complex, completely new pictorial poem. Although in painterly
terms too it is a tribute to late Titian, the plastic immediacy and the
orgiastic intensity in the revival of Antiquity, perceived as if it were
happening in the present, are all Rubens's own.

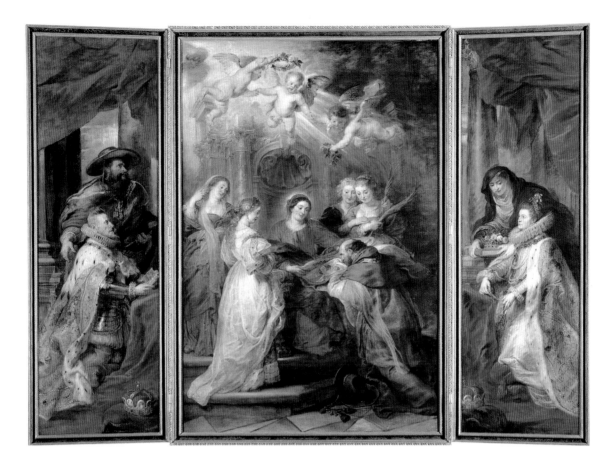

Peter Paul Rubens
Siegen 1577 - Antwerp 1640
Ildefonso altar, 1630/32
Oak, central picture 352 x 236 cm
both wings 352 x 109 cm
(Inv. no. 678)
Painted for the Lady Chapel, St Jacob op de
Coudenberg, Brussels, purchased 1777

The three-part altar, the masterpiece of Rubens's
late period, was commissioned in 1630 by the
Infanta Isabella Clara Eugenia in memory of
her husband, Archduke Albrecht, a brother of
Emperor Rudolf II. The archducal couple are
kneeling, protected by their patron saints and
become witnesses to St Ildefonsus's vision. The
Mother of God, surrounded by women with the
features of Ruben's young wife Hélène, appears
to the holy man, handing him a costly liturgical
vestment.

Peter Paul Rubens
Siegen 1577 - Antwerp 1640
Meeting of King Ferdinand of Hungary and the Cardinal Infante Ferdinand before the Battle of Nördlingen, 1634/5
Canvas, 328 x 388 cm
(Inv. no. 525)
In the imperial gallery in Vienna
in 1730

Part of the festive decoration which Rubens prepared for the solemn entry into Antwerp of the new Spanish Governor of the Netherlands, the Cardinal Infante Ferdinand, on 17 April 1635. At the Battle of Nördlingen on 6 September 1634 the combined Spanish and imperial armies inflicted a heavy defeat on the Swedes. In the foreground the river god Danubius and the figure of Germania mourn over the spilt blood.

Jacob Jordaens
Antwerp 1593 - Antwerp 1678
Feast of the bean king, c.1640/45
Canvas, 242 x 300 cm (Inv. no. 786)
Archduke Leopold Wilhelm collection
1659

The picture shows a popular Flemish custom on Twelfth Night. A bean is baked inside a cake and the person who finds it is king of the revels, the prettiest woman is the queen, and those sitting round the table are his royal household, in this case with small labels naming their individual offices. As regards content, the picture goes beyond the pure genre scene. The Latin motto underneath the satyr's mask indicates that mankind, represented here by the dissolute royal household of the bean king, is becoming deluded.

Peter Paul Rubens
Siegen 1577 - Antwerp 1640
The 'little fur', *c*.1635/40
Oak, 176 x 83 cm (Inv. no. 688)
Mentioned in Rubens's will (*Het Pelsken*)
and bequeathed to his wife Hélène
Fourment (1614-74), in the imperial
collections in Vienna in 1730

In *The 'little fur'* Vienna owns what must be
the most subtle mixture of a portrait and its
mythological travesty. It is still uncertain
whether the classical *Venus Pudica* has here
been given the features of Hélène Fourment,
or whether Rubens wanted to paint a portrait
of his wife and raise the intimacy of subjective
invention through elevating it by means of
mythology into something with universal
validity.

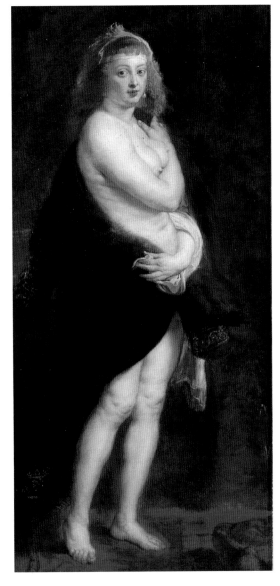

Peter Paul Rubens
Siegen 1577 - Antwerp 1640
Self-portrait, *c*.1638/40
Canvas, 109.5 x 85 cm (Inv. no. 527)
In the imperial collections in Vienna in 1720

'Reflective yet at the same time self-assured – idea and
reallity combined – (Rubens) wanted to face the world
as a man of absolute integrity.' (F. Klauner).

Jan Davidsz de Heem
Utrecht 1606 - Antwerp 1683/4
*Chalice and the host, surrounded
by garlands of fruit*, 1648,
signed and dated
Canvas, 138 x 125.5 cm
(Inv. no. 571)
Archduke Leopold Wilhelm
collection 1659
Painted for the archduke

Anthony Van Dyck
Antwerp 1599 - London 1641
*The mystic marriage of the Blessed
Hermann Joseph with Mary*, 1630
Canvas, 160 x 128 cm
(Inv. no. 488)
Painted for the Confraternity of
Bachelors in Antwerp in 1630,
purchased from the Jesuit order's
Professhaus (convent) in Antwerp
in 1776

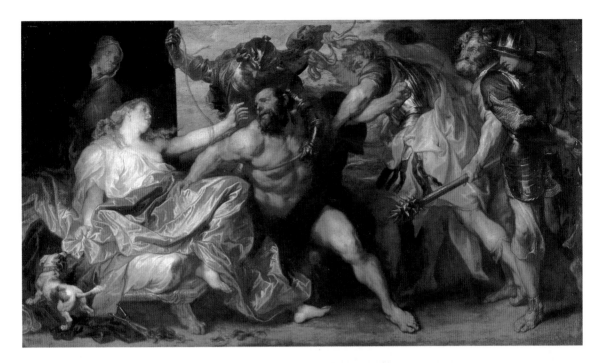

Anthony Van Dyck
Antwerp 1599 - London 1641
Samson and Delilah, c.1628/30
Canvas, 146 x 254 cm
(Inv. no. 512)
Archduke Leopold Wilhelm collection 1659

While Samson slept, his beloved Delilah cut off
the long hair which gave him superhuman strength,
so delivering him to his enemies, the Philistines.
Mainly following the model of Rubens, Van Dyck
alters his teacher's composition in a typical way:
instead of the heroic defensive fight, we have the
discovery of the treachery, the painful leave-taking
of the man betrayed from his beloved who has
tricked him, and the ambiguous way Delilah leans
towards her lover, defeated by treachery, in the
centre.

Anthony Van Dyck
Antwerp 1599 - London 1641
Portrait of a young general, c.1624
Canvas, 115.5 x 104 cm (Inv. no. 490)
In the imperial painting gallery in Vienna in 1720

In spite of his heroic demeanour the young man's expression
is subdued by a hint of melancholy, although this was also
sometimes suggested in the sixteenth-century Venetian
portraits on which this is modelled.

Anthony Van Dyck
Antwerp 1599 -
London 1641
*Nicholas Lanier, c.*1632
Canvas, 111 x 87.6 cm
(Inv. no. 501)
Collection of King
Charles I of England,
after the king's execution
acquired by Lanier in
1649, in the imperial
painting gallery in
Vienna in 1720

Lanier (1588-1666) was
the master of music at
the court of Charles I
of England and one of
his advisers on artistic
matters; he played a
considerable role in the
king's purchase of the
Duke of Mantua's
collections in 1627/8.

Anthony Van Dyck
Antwerp 1599 -
London 1641
Jacomo de Cachiopin,
*c.*1628/9
Canvas, 111 x 84.5 cm
(Inv. no. 503)
In the imperial painting
gallery in Vienna in 1720

The sitter (1578-1642),
an art lover and collector
of paintings from Antwerp,
was a friend of Van Dyck.
We experience the
painter's psychological
sensitivity as an expression
of introspection and
melancholy in the man
portrayed – characteristics
traditionally attributed to
the artist in general.

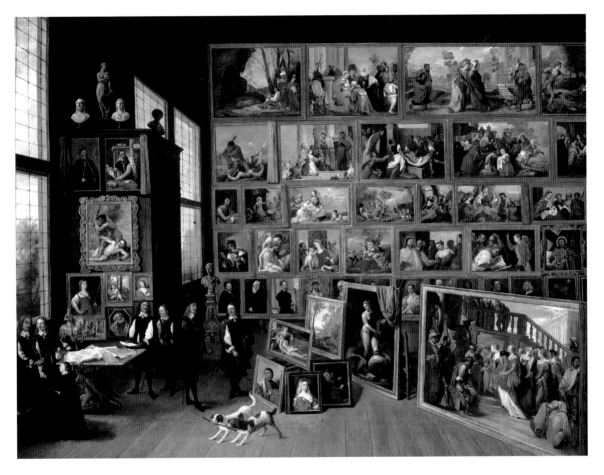

David Teniers the Younger
Antwerp 1610 - Brussels 1690
Archduke Leopold Wilhelm in his gallery in Brussels, c.1651
Canvas, 123 x 163 cm (Inv. no. 739)
Commissioned by Archduke Leopold Wilhelm; then in the
possession of his brother, Emperor Ferdinand III, in Prague

Leopold Wilhelm's court painter David Teniers shows the Archduke some
newly arrived pictures on the occasion of a (fictitious) visit to the gallery.
The arrangement of the gallery shown here certainly did not correspond
to reality. It is based on an earlier type of presentation used to depict the
interior of a collection. Almost all of the 51 pictures, frequently altered in
their relative dimensions, are in the Kunsthistorisches Museum today.

Dutch Painting

Just as it is wrong to describe the Dutch art of the seventeenth century as middle-class and the Flemish art of that period as courtly and aristocratic, it would be equally incorrect to perceive Dutch painting as solely interested in depicting the immediate human environment, in landscape, towns, the sea, the life of the people, while Flemish art devoted itself mainly to history painting, regarded by art theory as a more elevated genre. On the contrary, public buildings in Holland with a need to be imposing and rich citizens whatever their religious persuasion or origin required pictures with allegorical or religious themes.

Up until the early seventeenth century any division of the Netherlands school of painting into a Flemish and a Dutch section would be artificial in view of the constant interchange between the areas. For example Pieter Aertsen, who was born in Amsterdam, worked in Antwerp for twenty years before returning to his home town in 1557, and his pupil and nephew Joachim Buckelaer spent his whole life in Antwerp. Particularly after 1579/81 with the Union of Utrecht and the secession of the seven northern provinces a great many people emigrated from the southern Netherlands to the Protestant half of the artificially divided country.

The impetus for the independent development of Dutch painting always came from Flemish artists. Bartholomäus Spranger, who was born in Antwerp and trained in Rome, was the founder of a virtuoso, courtly and artificial style which became an international 'language' as a result of Spranger's sojourn in Vienna and Prague. In 1583 the painter and art theorist Karel van Mander brought this style to Haarlem. One of the main masters of this Haarlem or Utrecht Mannerism was Abraham Bloemaert.

Then again Esaias van de Velde, born in Holland as the son of Flemish emigrants and trained in the circle centred on the Flemish painters David Vinckboons and Gillis Coninxloo, in his early work developed a realistic style of painting referring back to Jan Bruegel the Elder, with a brightly coloured gradation of the pictural grounds. Around 1630 a tendency to unify the pictural space and let the colours of the different layers of the picture merge into one another became established in Holland. It was no longer the manifold nature of things that was being presented, but rather the experience of space and the atmosphere of the overcast expanse of cloud that were being conveyed in an increasingly monochrome use of colour. Esaias van de Velde took part in this stylistic change along with his pupil Jan van Goyen.

One of the most monumental high Baroque landscapes, *The great forest* by

Jan Vermeer van Delft
Delft 1632 - Delft 1675
*The artist in his studio
(Allegory of the art of painting)*,
(detail of page 91), c.1665/6,
signed
Canvas, 120 x 100 cm
(Inv. no. 9128)
Originally intended for the rooms of the Delft Guild of Painters. In the auction of Vermeer's estate in 1677. In the collection of Gottfried van Swieten in Vienna in the eighteenth century. Bought by Count Rudolf Czernin from a saddler in Vienna as a de Hooch in 1813. Acquired by the Kunsthistorisches Museum in 1946

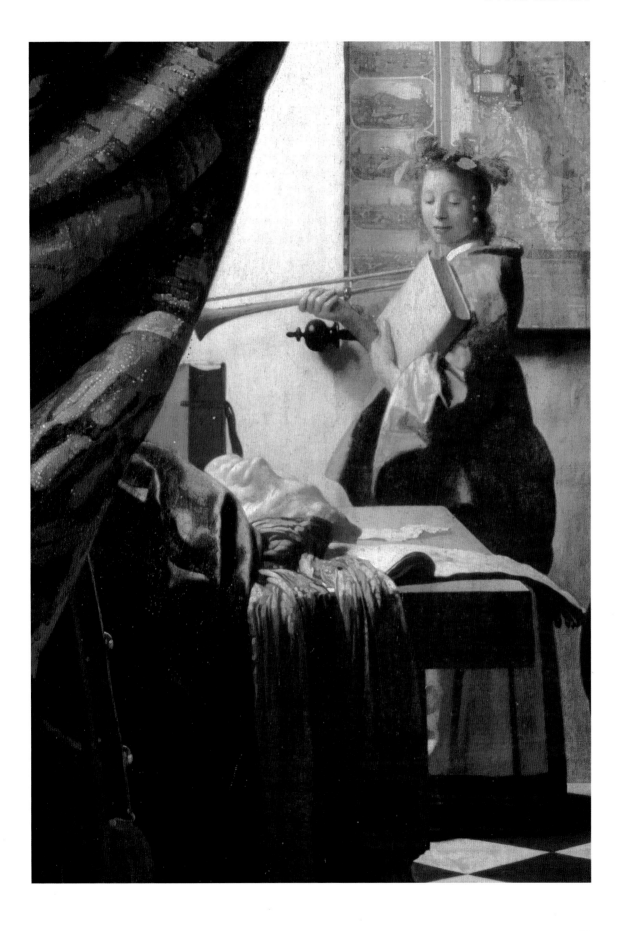

Jacob van Ruisdael, belongs to the next stage of development. We are no longer called on to experience the grey-brown, virtually amorphous expanse of space with few motifs to arrest our gaze; the fixed, energetically accentuated structure now determines the impression.

Dutch genre painting, which is in fact rarely just a portrayal of domestic life, often imparting a moralistic message, is represented in Vienna by all the main masters. Its centre was Leiden where Gerard Dou, Rembrandt's first pupil, became the founder of what was known as the Leiden school of *fijnschilders* (fine painters).

The three greatest Dutch figural painters, Frans Hals, Rembrandt and Jan Vermeer van Delft, followed one another with approximately a generation's interval between them. Hals was born in Antwerp and worked in Haarlem mainly as a portrait painter and for many has come to epitomize the vital and spontaneous extroverted virtuoso painter, as against Rembrandt the thinker – as the cliché would have it – whose art could plumb the origins of human destiny. This is both true and false. What is evident to the viewer of portraits or group portraits by Hals is his ability to confront us with human beings in movement and imbued with emotion. To suggest the fleeting moment Hals uses an open, seemingly irregular brushstroke crossing over itself in a zigzag or as hatching. Its effect is to produce a flickeringly restless, sketch-like surface which coalesces into a coherent corporeality only when viewed from a certain distance. The surely deliberate touch of pretension in the portrait of *Tieleleman Roosterman* is absent in the *Portrait of a man* painted some twenty years later. The portraits from Hals's late period come near to the works of Rembrandt in their psychological penetration and in dispensing with any kind of pose.

Using subtle gradations of tone and areas of penumbra Rembrandt's *chiaroscuro* seems to envelop the figures in a resonant space in which mood, emotion, atmosphere, something intangible or even invisible seem to reside. Rembrandt is represented in Vienna by portraits only, though those of *The artist's mother* and *The artist's son* could also be described as single-figure history paintings. In the so-called *Large self-portrait* of 1652 the painter confronts us in a three-quarter view, self-assured, in fact almost challenging, in his brown painter's smock.

Jan Vermeer's undramatic art, concentrating purely on looking, was regarded as a reflection of the Dutch middle class, now self-sufficient and satisfied with what they had. But the simplicity of Vermeer's pictorial concepts is deceptive. Their clarity and tranquillity is the result of carefully calculated consideration, also involving the use of newly developed technical aids such as the camera obscura. The *Allegory of painting* created *c.*1665/66, a high point in the use of colour in Vermeer's work, must also be his most ambitious picture. The process that had started with Jan van Eyck, a native of the northern Netherlands, the passive, distanced gaze at the immobilized world, always remained a fundamental theme of Dutch painting, and in the work of Vermeer became an allegorical as well as a real apotheosis of looking.

Pieter Aertsen
Amsterdam *c.*1508/9 -
Amsterdam 1575
Vanitas still-life, in the
background *Christ in the house
of Mary and Martha*, 1552,
signed and dated
Panel, 60 x 101.5 cm
(Inv. no. 6927)
Archduke Leopold Wilhelm
collection 1659. Bought back
for the Kunsthistorisches
Museum in 1930

The levels of meaning are also
separated by the different ways
of painting in the foreground
and the background. In the
foreground the festive preparations
for receiving Christ as a guest at
the house of the sisters Mary
and Martha are presented. The
actual scene – based on Luke
10:38-42 – can be seen behind
on the left, sketchily presented.
Christ chides Martha, who is
concentrating on material
things and busy about her work,
telling her not to criticize her
contemplative sister for her
inactivity.

Joachim Bueckelaer
Antwerp *c.*1530 -
Antwerp 1574
Peasants at market, 1567,
monogrammed and dated
Panel, 109 x 140 cm
(Inv. no. 964)
In the imperial painting
gallery in 1824

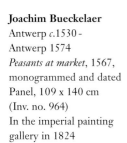

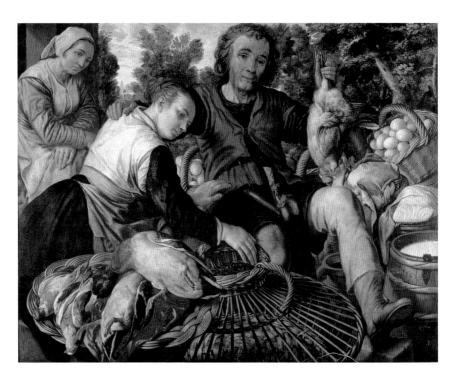

Abraham Bloemaert
Gorinchem 1564-
Utrecht 1651
Judith showing the people the head of Holofernes, 1593, monogrammed and dated
Panel, 34.5 x 44.5 cm
(Inv. no. 6514)
Acquired 1926

Bloemaert turns the Old Testament scene, with the Jewish heroine Judith displaying to her people the head of the enemy Assyrian general Holofernes which she herself has cut off, into a showpiece with light effects. The interweaving, often very foreshortened or animatedly moving figures in surprising lighting situations heighten the drama of the action.

Esaias van de Velde
Amsterdam 1590-
The Hague 1630
John the Baptist preaching, early work
Panel, 69 x 96 cm
(Inv. no. 6991)
Gift from Galerie St Lucas, 1940

Jan van Goyen
Leiden 1596 - The Hague 1656
View of Dordrecht across the river Merwede, 1644,
monogrammed and dated
Canvas, 103.5 x 133 cm
(Inv. no. 6450)
Acquired from the Frits Lugt collection in 1923

Goyen's seascape painted in 1644 is a late example of the 'tonal' phase of Dutch landscape painting.

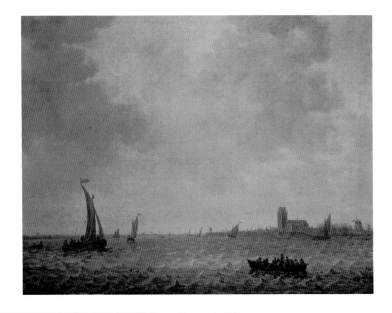

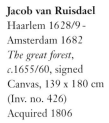

Simon de Vlieger
Rotterdam 1601 - Weesp 1653
Visiting the fleet, 1649, signed and dated
Oak, 71 x 92 cm (Inv. no. 478)
Acquired 1850

The picture shows Admiral and Governor Frederik Hendrik II of Orange (1583 - 1647) visiting the Dutch inshore fleet off Dordrecht in June 1646. Frederik Hendrik sits in the front boat turned towards the viewer, with his hat and osprey feathers. To the left of centre his state yacht with the coat-of-arms of the House of Orange. The picture is the prototype for a series of pictures on the popular theme of visiting the fleet.

Jacob van Ruisdael
Haarlem 1628/9 - Amsterdam 1682
The great forest, c.1655/60, signed
Canvas, 139 x 180 cm
(Inv. no. 426)
Acquired 1806

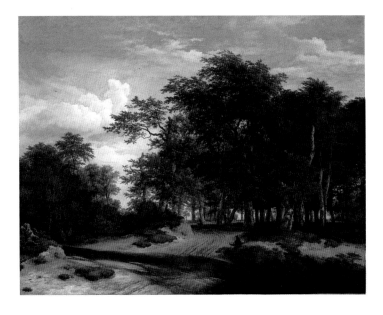

Frans van Mieris
Leiden 1635 - Leiden 1681
The gentleman in the shop, 1660, signed and dated
Panel, 54.5 x 42.7 cm (Inv. no. 586)
Acquired by Archduke Leopold Wilhelm in 1660

Gerard Dou's pupil Frans van Mieris is openly observing present erotic pleasures.

Gerard Dou
Leiden 1613 - Leiden 1675
Old woman at her window, watering flowers, c.1660/65, monogrammed
Panel, 28.3 x 22.8 cm (Inv. no. 624)
Acquired 1811

The jug, flower-pot and bird-cage as 'attributes' of the old woman may allude to past joys of love, or indeed to transitory memories.

Samuel van Hoogstraten
Dordrecht 1626 - Dordrecht 1678
Man looking through a window, 1653, monogrammed and dated
Canvas, 111 x 86.5 cm (Inv. no. 378)
Painted in Vienna, imperial Treasury in Prague, in the imperial painting gallery in Vienna in 1781

Traditionally the man portrayed is believed to be Rabbi Jom-Tob Lipmann Heller (1579-1654) who worked in Vienna, Prague and Cracow, though he was not in Vienna in 1653. Hoogstraten specialized in illusionistic (*trompe-l'oeil*) depictions of objects which excited amazement because they were so 'true to life'.

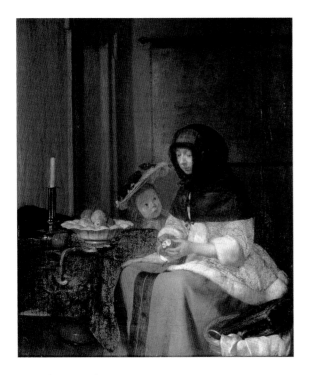

Gabriel Metsu
Leiden 1629 - Amsterdam 1667
Noli me tangere,
1667, signed and dated
Panel, 63.7 x 51 cm (Inv. no. 6044)
Bequest 1907

Gerard ter Borch
Zwolle 1617 - Deventer 1681
Woman peeling an apple, c.1661
Canvas on panel, 36.3 x 30.7 cm (Inv. no. 588)
In the imperial painting gallery in 1781

Even if it looks as if Gerard ter Borch is cosily depicting a
child inquisitively and greedily watching its young mother
as she peels an apple, the moral of the scene is more of a
warning not to give anyone all that his heart desires, but
above all not to accede to all one's own wishes. The care
and responsibility of parents for their children are often
a theme in Dutch genre painting, which enters its classic
phase with ter Borch.

Aert van der Neer
Amsterdam 1603/4 -
Amsterdam 1677
Fishing by moonlight,
c.1665/70,
monogrammed
Canvas, 66.5 x 86.5 cm
(Inv. no. 6487)
Acquired 1924

Jan Steen
Leiden 1625/6 - Leiden 1679
Topsy-turvy world, 1663, monogrammed and dated
Canvas, 105 x 145 cm (Inv. no. 791)
Collection of Charles, Duke of Lorraine 1779. Acquired 1780

The traditional title of the picture is not quite apt because it
depicts a disorderly household. While the housewife and mother
has fallen asleep at the table, mayhem is breaking out all around.
The motto is the part of a Dutch proverb which is written on
the slate at the bottom right, 'In high living beware', which is
completed by 'and fear the rod', and the rod too is hanging from
the ceiling in a basket, along with a sword and a walking stick.

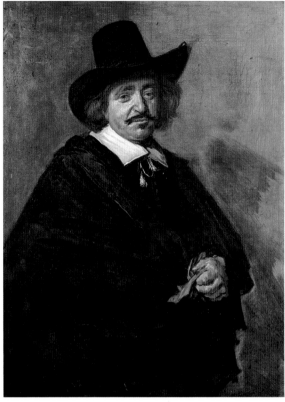

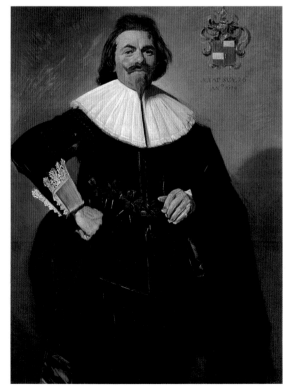

Frans Hals
Antwerp 1581/5 - Haarlem 1666
Portrait of a man, *c*.1654/5
Canvas, 108 x 79.5 cm (Inv. no. 9091)
Auction of the Gsell collection, Vienna, 1872; collection of
Baron Albert von Rothschild, Vienna; gift of Baron Louis
de Rothschild 1947

Hals contrasts the plump, firmly modelled fleshy face with
the flat outline of the black figure, which in turn stands out
against the light spaceless background. The pale hand,
drawn with incredible confidence and vibrancy, sits almost
like a storm centre in the middle of its black surroundings.

Frans Hals
Antwerp 1581/5 - Haarlem 1666
Tieleman Roosterman, 1634, dated
Canvas, 117 x 87 cm (Inv. no. 9009)
Auction of the Gsell collection, Vienna, 1872; collection
of Nathanael and Alphonse de Rothschild, Vienna; gift of
Clarisse de Rothschild 1947

In this portrait Hals's early bright palette has already been
reduced to a black and white scale which he handles with
virtuosity.

Rembrandt Harmensz van Rijn
Leiden 1606 - Amsterdam 1669
The artist's mother as the prophetess Hannah, 1639,
signed and dated
Panel, cut as an oval, 79.5 x 61.7 cm (Inv. no. 408)
Brought from the castle in Pressburg (now Bratislava)
to the imperial painting gallery in Vienna in 1772

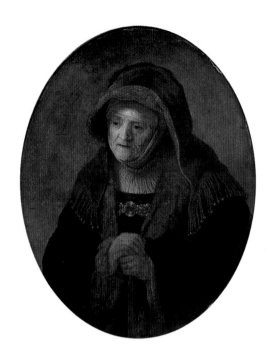

Rembrandt's mother is depicted in her 71st year, a
year before her death. With the Jewish prayer scarf
round her she is 'disguised' as the prophetess Hannah
from the Gospel according to St Luke. Although the
most recent complete catalogue of Rembrandt's works
has relegated this famous picture to the category of a
studio product, it might be regarded as his own work
because of its high quality.

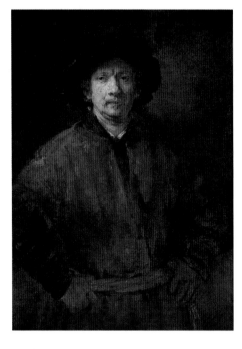

Rembrandt Harmensz van Rijn
Leiden 1606 - Amsterdam 1669
The artist's son, Titus van Rijn, reading, c.1656/7
Canvas, 70.5 x 64 cm (Inv. no. 410)
In the imperial painting gallery in 1720

Titus van Rijn was born in 1641, the fourth
child of Rembrandt and his first wife Saskia van
Uylenburgh and the only one of their children
to reach adulthood. Titus and Rembrandt's last
companion Hendrickje Stoffels took over the
'business' after Rembrandt's bankruptcy in 1656,
with the painter working as an employee.

Rembrandt Harmensz van Rijn
Leiden 1606 - Amsterdam 1669
The large self-portrait, 1652, signed and dated
Canvas, 112 x 81.5 cm (Inv. no. 411)
In the imperial painting gallery in 1720

This portrait was painted in the year when Rembrandt's
financial difficulties were starting, and in contrast to
the rich clothing he had frequently worn earlier the
artist presents himself to the viewer 'dressed for work'
in his painter's smock, self-confident and full-face.
The palette has been reduced to brown and black
tones in differentiated gradations, the brushstrokes are
no longer applied following the detail, rather in a flat,
broad, pastose manner, drawing form only in the
luminously and plastically elaborated face.

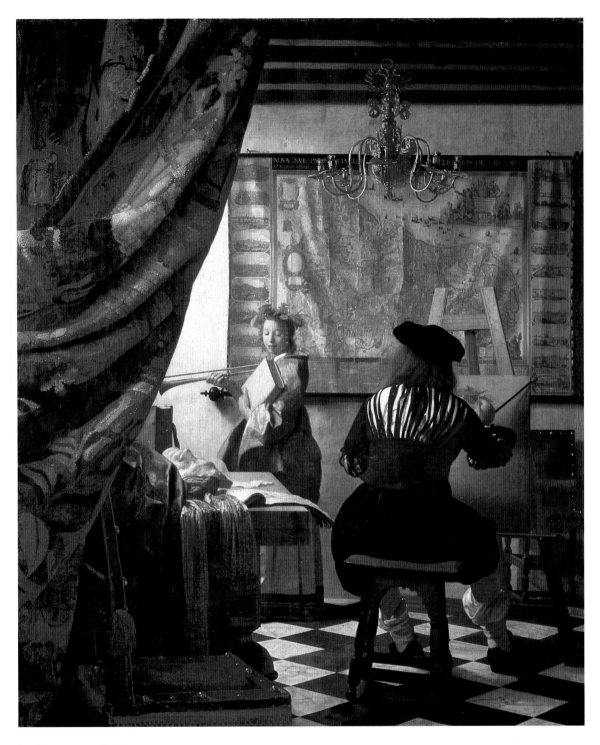

Jan Vermeer van Delft
Delft 1632 - Delft 1675
The artist in his studio (Allegory of painting), c.1665/6, signed
Canvas, 120 x 100 cm (Inv. no. 9128)

The layers of meaning in the allegory are overlaid on one another in a complicated way. Clio, the Muse of History, poses as the painter's model. The objects spread out on the table – a treatise on painting, a mask or sculptor's model, a sketchbook and the map of the seventeen provinces of the Netherlands before their separation in 1581 – should also be woven into the interpretation. Thus the Muse of History inspires the painter while at the same time proclaiming the fame of the art of painting in the old Netherlands which she is entering into the book of history.

German Painting

The German painting section is particularly rich in pictures by Albrecht Dürer, the two Cranachs and Holbein the Younger; the so-called Danube School and Augsburg portrait painting of the sixteenth century are also well represented. The collection of Baroque painting lacks unity, but in this it is typical of German art, especially seventeenth-century German art. This German section is completed by representatives of international neo-classicism in the late eighteenth century. For historical reasons, relating to political developments after World War I, the Paintings Collection of the Kunsthistorisches Museum now has no examples of fifteenth and eighteenth-century Austrian painting, a very important area. Consisting partly of works from the imperial collections, it is exhibited in an administratively independent 'national gallery', the Österreichische Galerie at Schloss Belvedere in Vienna.

Martin Schongauer, who was born in Alsace, finally led German painting out of its somewhat provincial state at the end of the fifteenth century. It was first and foremost Schongauer who prepared the ground for the synthesis of the styles of the Netherlands and Italy which Dürer was then able to achieve. In the *Holy Family*, for all its dependence on Rogier van der Weyden's expressive forms, the warm light with the shadows it casts, the deep luminous colouring, the intercircling lines of the folds and the detailed apparatus of 'graphic' forms give rise to a completely individual, confiding, comfortable atmosphere quite different from its model.

Apart from the *Portrait of a young Venetian lady*, all the paintings by Albrecht Dürer in Vienna used to belong to the imperial collection; in almost every case their acquisition can be traced back to Rudolf II's insistent love for everything associated with the name of Dürer. With one exception these are works painted after Dürer's second journey to Venice, i.e. 1505/6.

There can be no doubt that *The All Saints altarpiece (Adoration of the Trinity)* dated 1511 is the high point of the Dürer collection in Vienna. Dürer – who depicts himself in the empty 'New Earth' brought back to life in the sunrise after the Last Judgement – and the viewer experience this vision of the 'City of God' according to Augustine, in which 'the wondrous seems near and the familiar seems remote' (Wölfflin). Shortly before that Dürer had portrayed himself amidst the cruel events in the *Martyrdom of the 10,000 Christians*, along with his humanist friend Conrad Celtis. The martyrdom of the 10,000 Christians which is depicted with a wealth of detail – Elector Frederick the Wise of Saxony who commissioned the picture from

Albrecht Dürer
Nuremberg 1471-
Nuremberg 1528
The All Saints altarpiece
(detail of page 96),
1511, signed and dated
Limewood,
135 x 126.3 cm
(Inv. no. 838)

ALBERTVS·DVRER
NORICVS·FACIE
BAT·ANNO·A·VIR
GINIS·PARTV
·1511·

Albrecht Dürer
Nuremberg 1471-
Nuremberg 1528
*Martyrdom of the
10,000 Christians*,
1508, signed and dated
Panel transferred to
canvas, 99 x 87 cm
(Inv. no. 835)
Painted for Elector
Frederick the Wise of
Saxony for the castle
church in Wittenberg. A
gift from John Frederick
of Saxony to Nicolas
Perrenot de Granvelle,
chancellor to Emperor
Charles V; collection
of Cardinal Granvelle,
acquired by Emperor
Rudolf II from Count
Cantecroy, a nephew of
Granvelle, in Besançon
in 1600, in the Vienna
Treasury in 1677

Achatius, who had
converted to Christianity,
and his soldiers were
martyred on Mount
Ararat on the orders of
the Persian king Sapor;
they were crucified,
stoned and pushed into
thorn bushes. Elector
Frederick the Wise,
who gave Dürer the
commission, had a huge
collection of relics
including relics of these
10,000 Christians and
their leader. But the small
altarpiece, undoubtedly
with the Elector's
knowledge, is also a
memorial to Dürer's
humanist friend Conrad
Celtis who had died
recently; Dürer depicts
Celtis as well as himself
amidst the turbulent
events.

Dürer had some of their bones in his famous collection of relics – is transformed
into an exemplary Passion following in the footsteps of Christ.

The influence of Italian painting, Venetian in this case, can be seen in the not
quite completed *Portrait of a young Venetian lady*, especially in the sensuous qualities of
the surface of the skin and the attractive young woman's hair, and in the softer light
enveloping the form; and the same is true of the physical heaviness of the child
with his complicated movement in the *Madonna with the pear* dating from 1512,
with its reminiscences of Michelangelo. While in Italy Dürer had become receptive
to such influences. One of the most fascinating portraits of the German Renaissance
is Dürer's late portrait of the enigmatic *Johann Kleberger*; much of the shadiness of
his character may also have been put into the form of the portrait.

From the first decade of the sixteenth century a style developed which is usually
named after the geographical area in which it became widespread, the 'Danube'
style. Its main artistic inspiration was, above all, Dürer's series of woodcuts on the
Apocalypse. Its principal exponents were Lucas Cranach who was born in Franconia,
Albrecht Altdorfer from Regensburg and Wolf Huber who came from Feldkirch in
Vorarlberg and spent much of his life in Passau. This style grew out of the infinitely
varied late Gothic wealth of forms but differs from all that had preceded it in the

completely new relationship to nature, landscape in particular.

The works of the young Lucas Cranach are crucial to the first phase, created in Vienna between 1500 and 1503 on his journeyman's travels, including the *Crucifixion* reproduced here. In Altdorfer and his school this expressive stylistic trend was accentuated still further. There is a small panel from the predella of his masterpiece, the St Sebastian altar completed in 1518 for St Florian Abbey in Upper Austria, on which the overwhelming miracle of light in the *Resurrection* appears reflected in nature, in the glowing red-gold sky. This powerful, emotionally charged style was also highly prized in the humanist circle centred on the Prince Bishop of Passau, Count Wolfgang I Salm. The large *Allegory of salvation* by Wolf Huber and his severe classical portrait of the geographer and astronomer *Jacob Ziegler*, in which the head of the scholar is placed as if it were transparent in front of an unending blue-tinged landscape, are examples of this romantic yet scholarly style.

After he took up the post of court painter to Elector Frederick the Wise of Saxony in Wittenberg in 1504, Lucas Cranach basically turned away from the expressive style of his early period; the preoccupation with nature can still best be recognized in the *Stag hunt of Elector Frederick the Wise*. From then until his death there was hardly any further change in his pictorial language, very impressive in the sustained typology of the models and aiming to achieve a decorative surface effect. The painter's field of work at the Saxon court included cabinet pictures in the spirit of humanism, with the female nude in the most varied 'disguises' playing an important role, and didactically moralizing pictures in the spirit of the Reformation, such as the Old Testament heroine *Judith*, as well as portraits.

Albrecht Dürer
Nuremberg 1471-
Nuremberg 1528
Portrait of Johann Kleberger, 1526, monogrammed and dated
Limewood, 37 x 36.6 cm
(Inv. no. 850)
In the possession of David Kleberger, the sitter's son, in Lyons; collection of Willibald Imhoff, Kleberger's stepson, Nuremberg, 1564, from which Emperor Rudolf II acquired it in 1588; in the Vienna gallery in 1748

Kleberger (1486-1546) was a rich and unscrupulous businessman and at the same time a benefactor of the poor. Dürer's strange form of portrait seems to suit the life of this unusual man. The formal sources are antique coins, contemporary portrait medallions, Northern Italian busts in front of circular marble panels and Marcantonio Raimondi's engravings of Roman emperors. Dürer may also have been entering into the art theory 'contest' between painting and sculpture, the *paragone*, attempting as a painter to surpass sculpture through the sensuous surface and the colour.

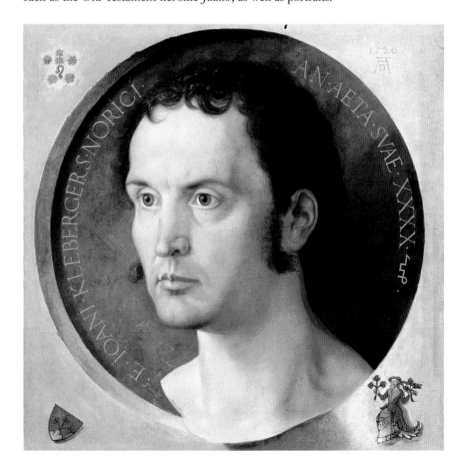

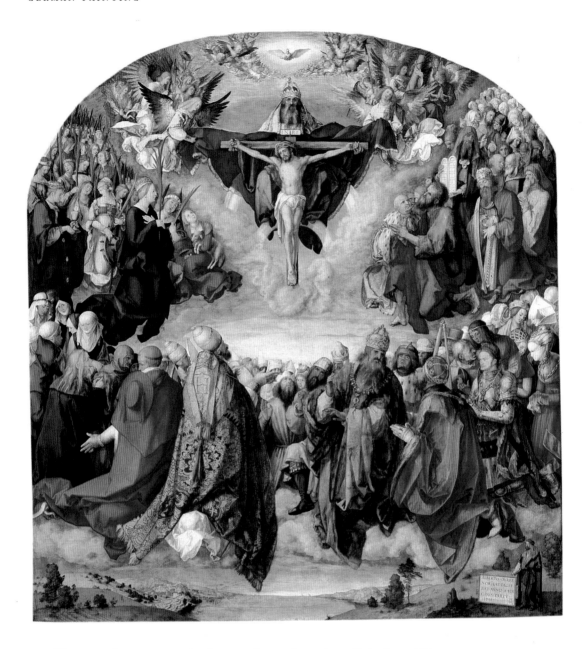

There was almost a generation between Dürer, Cranach or Altdorfer and Hans Holbein the Younger. He is represented in Vienna by seven portraits dating from his late period in England. Of all German painters he can surely be described as the artist who is closest to the classical sense of form. With an objective gaze that keeps its distance, but at the same time with extreme immediacy, Holbein confronts us with the members of the English court or the merchants at the 'Stahlhof', the German trading agency in London. Just as his portrayal of *Jane Seymour*, Henry VIII's third wife, is humanly touching, warm and protective, so the form and characterization in his latest portraits such as the *Young merchant* of 1541 are unrelenting. In the latter, the beautiful roman script running across the neutral ground serves to fix the plastic form in the picture surface in geometric terms. A comparison with the *Ziegler portrait* by Wolf Huber which was painted very shortly afterwards demonstrates the great range of possibilities in German portrait painting and the diversity in the way the Italian Renaissance was assimilated.

Albrecht Dürer
Nuremberg 1471-
Nuremberg 1528
The All Saints altarpiece,
1511, signed and dated
Limewood, 135 x 126.3 cm
(Inv. no. 838)
Altarpiece for the
All Saints' chapel at
the Zwölfbrüderhaus
Foundation in Nuremberg,
donated by Matthäus
Landauer, bought from
the foundation by
Emperor Rudolf II in
1585; in the Sacred
Treasury in Vienna in
the eighteenth century,
in the gallery in 1780

The truly universal
concept is based on
St Augustine's ideas
regarding the City of
God. It anticipates the
state of the *Civitas Dei*
after the Last Judgement
when the earthly Christian
community consisting
of popes, emperors, the
estates and the donors of
the altar and the heavenly
community of all the
saints, led by Mary and
John the Baptist, will
have united in worshipping
the Trinity. In the bottom
row on the left is the
donor of the altar,
Matthäus Landauer, who
commissioned the picture
in 1508, and on the right
in armour his son-in-law
Wilhelm Haller.

In comparison with Holbein's tender objectiveness and exactness of reproduction while preserving the large form, the south German portraits by Christoph Amberger, Barthel Beham or Hans Muelich are more additive, sometimes bombastic in their enunciation of their content and their style. More clearly than in Holbein's works they are dependent on Italian and Flemish models from the early and mid-sixteenth century. All the same these portraits attest to the high painterly attainments demanded in the towns and courts of southern Germany.

Let us now consider five painters from the seventeenth century who demonstrate in exemplary fashion how heterogeneous German painting virtually had to be in that century, and how 'German' had more or less lost its meaning as a stylistic concept in a country whose cultural life was paralysed by wars and political turmoil.

Joachim von Sandrart represents the type of the *peintre chevalier*, or gentleman painter. As a courtier, antiquarian, landowner, art theorist and writer he was widely travelled and had observed the whole spectrum of European painting in a rationalist spirit. His style as a painter remained peculiarly uncertain and hybrid, although the Flemish component resulting from his early training in the Netherlands always remained discernible.

The most artistically productive years of Johann Heinrich Schönfeld's career were between 1633 and 1651 when the artist from Lake Constance was working in Rome and more particularly in Naples. His imaginative compositions full of antique reminiscences, with figures in slightly mannered, graceful poses, and highly individual, shimmeringly delicate colouring dominated by blue can be admired especially in the many-figured Old Testament and mythological pictures.

The works of Christoffer Paudiss, who came from Lower Saxony, studied with Rembrandt in the 1640s and worked in Dresden, Vienna and Freising (Bavaria), are often disconcerting because of the extreme precision with which he depicts cruel martyrdoms, poverty stripped of any genre trappings, and abject isolation.

One of the most individual painters in the inevitably disparate assembly of seventeenth-century German painters is Wolfgang Heimbach, who was born in Oldenburg. He travelled widely in Holland, central and northern Europe, but also in Italy, and his handicap is mentioned in all written sources: he was a deaf mute. In many of his pictures, though particularly in the *Nocturnal banquet*, for all the turbulence of the feast, the brightly coloured costumes, the movements and management of light, a strange lack of sound, a rigidity of typology and monotony in the movements can be sensed which may be connected to the restricted way he registered his surroundings.

Unlike Paudiss and Heimbach, Johann Carl Loth was not a loner: he was in fact head of a workshop in Venice frequented primarily by 'northerners'. As a point of synthesis and an intermediary agency this workshop was able to exert a crucial influence on eighteenth-century south German and Austrian painting.

Like Sandrart, the German-Roman painter Anton Raphael Mengs at the end of the eighteenth century was a scholar, an acclaimed painter prince, a writer, theorist, court painter and academy professor, and we would scarcely be justified in describing his art as German.

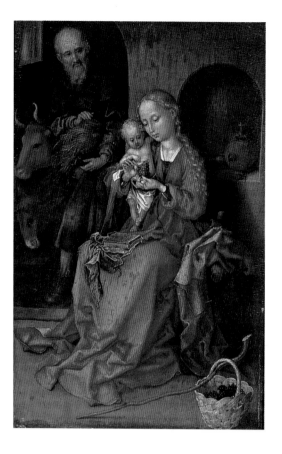

Martin Schongauer
Colmar 1450/53 - Breisach 1491
Holy Family, 1480/90
Panel, 26 x 17 cm (Inv. no. 843)
Acquired in 1865

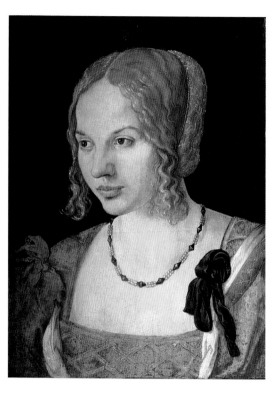

Albrecht Dürer
Nuremberg 1471 - Nuremberg 1528
Portrait of a young Venetian lady, 1505,
monogrammed and dated
Spruce, 32.5 x 24.5 (Inv. no. 6440)
In the collection of Bürgermeister Schwartz in
Danzig at the end of the eighteenth century,
acquired from a private Lithuanian owner in 1923

Must have been painted shortly after Dürer's arrival
in Venice.

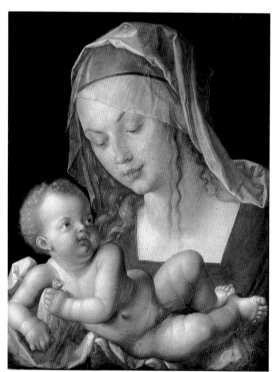

Albrecht Dürer
Nuremberg 1471 - Nuremberg 1528
Madonna with the pear, 1512, signed and dated
Limewood, 49 x 37 cm (Inv. no. 848)
Probably acquired by Rudolf II in 1600

A picture that virtually symbolizes Dürer's stylistic
tendencies: on the one hand the late Gothic legacy
in the delicately tender Madonna, and on the other
the massive, lively, three-dimensional Christ Child
clearly revealing Italian roots.

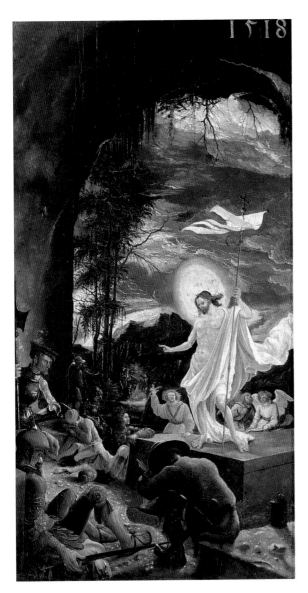

Albrecht Altdorfer
Regensburg(?) c.1480 - Regensburg 1538
Resurrection of Christ, 1518, dated
Spruce, 70.5 x 37 cm (Inv. no. 6796)
Part of the predella of the polyptich at
St Florian, Upper Austria. From St Florian 1930

Only two small predella panels from Altdorfer's
masterpiece, the great altar with scenes from the
Passion and the legend of St Florian, which is also
the crowning achievement of the Danube School
as a whole, came to the Kunsthistorisches Museum.
Today the altar itself can still be admired in the
museum of the abbey of Augustinian canons at
St Florian.

Lucas Cranach the Elder
Kronach 1472 - Weimar 1553
Crucifixion, c.1500/1501
Limewood, 58.5 x 45 cm
(Inv. no. 6905)
Recorded in the Schottenstift
in Vienna from 1800.
Acquired in 1934

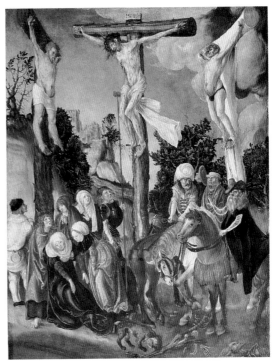

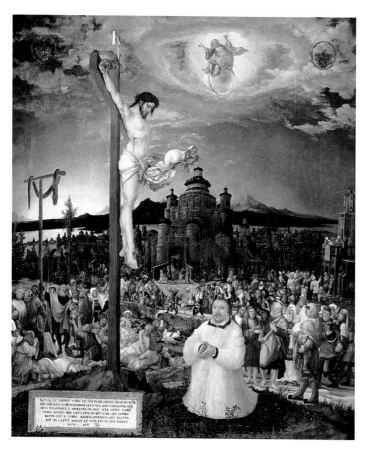

Wolf Huber
Feldkirch *c.*1485 - Passau 1553
*Allegory of salvation, c.*1540
Limewood, 154 x 130 cm (Inv. no. 971)
Transferred from the Sacred Treasury to
the imperial painting gallery in 1781

Taking Peter's announcement of salvation in
front of the Jewish High Council (Acts 4:
10-12: text on the inscription panel) as the
point of departure, the Crucifixion and the
typological parallel from the Old Testament,
the erection of the Brazen Serpent, are
juxtaposed. In the background the healing
of the lame and the imprisonment of the
apostles Peter and John. At the front the
kneeling figure of the donor, Count Wolfgang
I Salm, Prince Bishop of Passau from 1540
to 1555.

**Lucas Cranach
the Elder**
Kronach 1472-
Weimar 1553
*Stag hunt of Elector
Frederick the Wise*, 1529,
described and dated
Limewood, 80 x 114 cm
(Inv. no. 3560)
In the imperial collections
in Prague in 1621

Among the huntsmen
are Elector Frederick
the Wise (d.1525) and
Emperor Maximilian I
(d.1519), and on the right
Elector John the Steadfast.
Based on those depicted
as taking part in the hunt
who were already dead in
1529, it is obviously a
picture commissioned by
John the Steadfast to
commemorate a hunt
that had taken place long
before.

**Lucas Cranach
the Elder**
Kronach 1472 -
Weimar 1553
*Judith with the head
of Holofernes*, c.1530,
described
Limewood, 87 x 56 cm
(Inv. no. 858)
In the imperial
collections in Vienna
c.1615

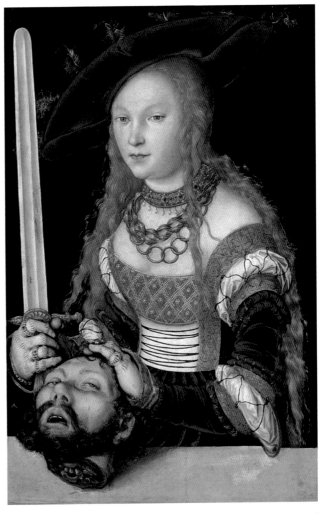

Wolf Huber
Feldkirch c.1485 - Passau 1553
Portrait of Jacob Ziegler, 1544/9
Limewood, 58.5 x 44.3 cm (Inv. no. 1942)
From the Paintings Collection store

Jacob Ziegler (1470/71 - 1549) was born in Landau
an der Isar and educated under Conrad Celtis in
Vienna. The versatile scholar, whose most interesting
achievements were in the fields of geography and
astronomy, worked at the court of Count Wolfgang I
Salm, Prince Bishop of Passau, from 1544.

**Hans Holbein
the Younger**
Augsburg 1497 -
London 1543
*Portrait of Jane Seymour,
Queen of England*, 1536
Oak, 65.4 x 50.7 cm
(Inv. no. 881)
Almost certainly in the
collection of Thomas,
Earl of Arundel, in 1654;
recorded in the imperial
collections from 1720

Jane Seymour (*c.* 1509 - 37)
went to court in London
in 1530, serving as a
lady-in-waiting to Queen
Catherine of Aragon and
Queen Anne Boleyn.
Henry VIII married her
in 1536, and she died in
1537 after giving birth to
the future King Edward
VI. One of Holbein's first
portraits after becoming
court painter to Henry
VIII in 1536.

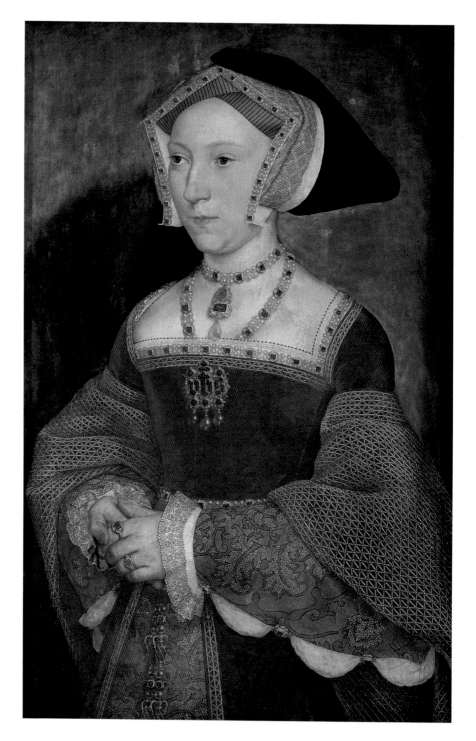

Hans Holbein the Younger
Augsburg 1497 - London 1543
Portrait of a young merchant, 1541, dated
Oak, 46.5 x 34.8 cm (Inv. no. 905)
Archduke Leopold Wilhelm collection 1659

Said to be the portrait of the Nuremberg
patrician Hans von Muffel (d.1565).

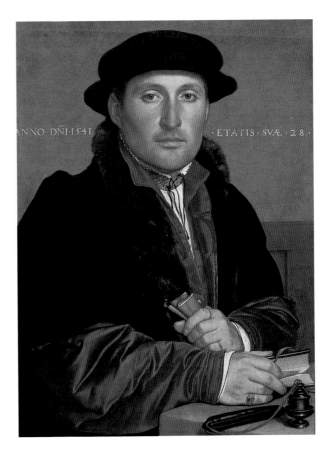

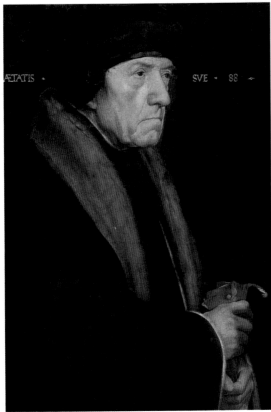

Hans Holbein the Younger
Augsburg 1497 - London 1543
Dr John Chambers, 1543
Oak, 57.8 x 39.7 cm (Inv. no. 882)
Collection of Thomas, Earl of Arundel, 1654;
Archduke Leopold Wilhelm collection 1659

One of the latest, most mature of Holbein's
portraits, depicting Henry VIII's physician
(1470 - 1549), Dean of the Royal Chapel and
the Council at Westminster Hall, at the age
of 73 (the numbers on the portrait regarding
his age have been filled in wrongly).

Lucas (Laux) Furtenagel
Augsburg(?) 1505 - Augsburg after 1546
The painter Hans Burgkmair and his wife Anna, née Allerlai,
1529, signed and dated
Limewood, 60 x 52 cm (Inv. no. 924)
In the imperial collections in Prague in 1685;
in Vienna in 1781

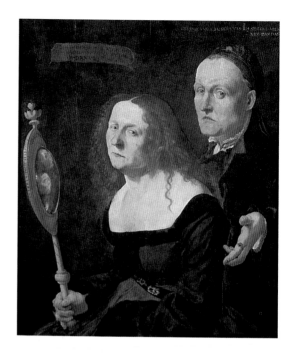

The only confirmed painting by this artist depicting the
Augsburg painter Hans Burgkmair in his 56th year and
his wife in her 52nd. On the mirror an allusion to the
transience of the world: 'Recognize thyself/oh death/hope
of the world', which is completed by the comment of both
husband and wife, expressing self-awareness and composure
in the face of death: 'This was how we two looked. But then
in the mirror there is nothing other than a skull.' Before the
signature was discovered it was believed to be a work by
Burgkmair himself.

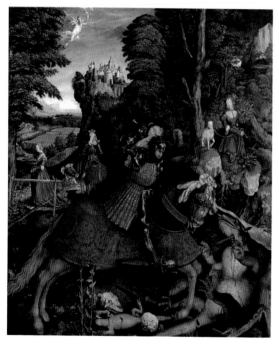

Barthel Beham
Nuremberg 1502 - Bologna 1540
Portrait of an umpire, 1529, dated
Limewood, 84.8 x 66 cm (Inv. no. 783)
In the imperial gallery in Vienna in 1781

The man depicted kept the score in archery
or at a ball game.

Leonhard Beck
Augsburg *c.*1480 - Augsburg 1542
*St George and the dragon, c.*1515
Spruce, 134.5 x 116 cm (Inv. no. 5669)
Ambras collection

The painter sets the legendary fight with the dragon in
wooded landscape like a chivalric fairy-tale. Emperor
Rudolf II's court painters must have been familiar with this
picture: the angel above is in a style that recurs in the work
of Hans von Aachen, and the landscape in the background
appears in a picture by Bartholomäus Spranger.

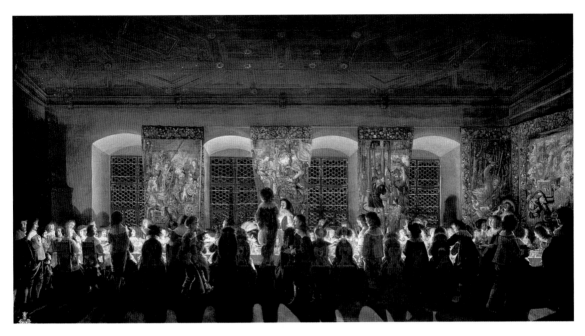

Wolfgang Heimbach
Ovelgönne/Oldenburg *c*.1600/1615 -
after 1678
Nocturnal banquet, 1640, signed and dated
Copper, 62 x 114 cm (Inv. no. 599)
Recorded as being in the imperial painting
gallery in Vienna in 1772

According to new research this depicts
a banquet for a Turkish embassy in the
Ritterstube of the Old Hofburg in Vienna.
The precise rendering of the Brussels
tapestries dating from *c*.1560 should be
noted.

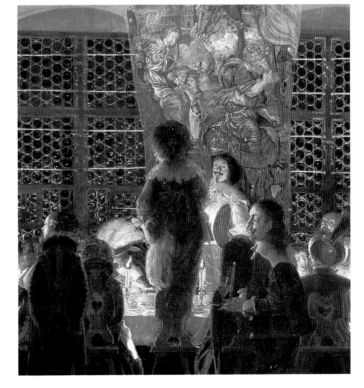

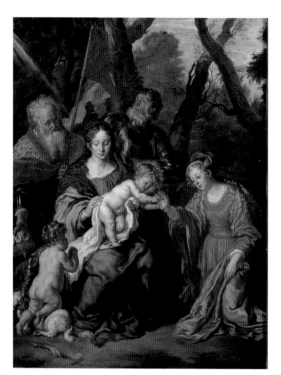

Joachim von Sandrart
Frankfurt am Main 1606 - Nuremberg 1688
The mystic marriage of St Catherine, with
SS Leopold and William, 1647, signed and dated
Maple wood, 74 x 57 cm (Inv. no. 1117)
Painted for Archduke Leopold Wilhelm,
given to Emperor Ferdinand III in Prague,
in Vienna in 1781

Christoffer Paudiss
Lower Saxony *c.*1625 - Freising 1666
Martyrdom of St Thiemo, 1662,
signed and dated
Canvas, 336 x 191 cm (Inv. no. 2284)
Acquired from the Prince Bishop's
Residenz in Salzburg, 1806

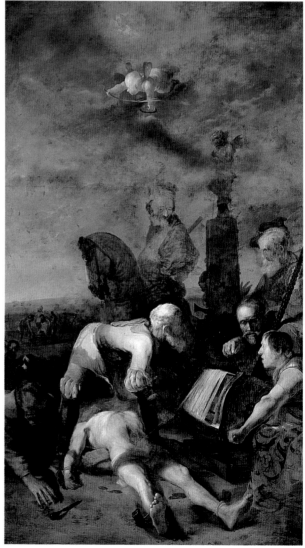

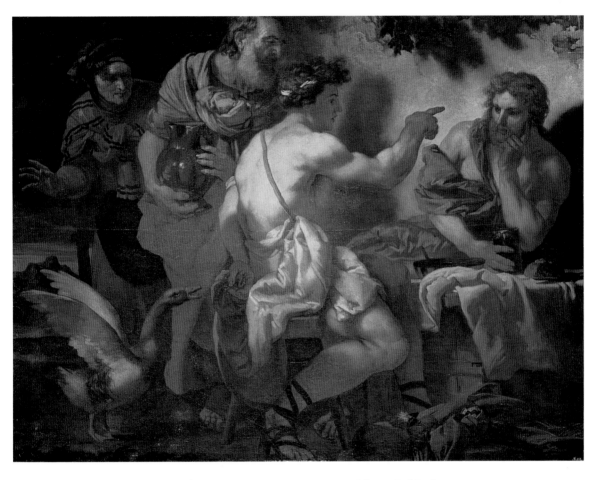

Johann Carl Loth
Munich 1632 - Venice 1698
Jupiter and Mercury being entertained by
Philemon and Baucis, 1659/62
Canvas, 178 x 252 cm (Inv. no. 109)
Archduke Leopold Wilhelm collection, addition

Loth's art was infuenced by Rome and especially by
Venice. He took up residence there soon after 1656,
directing a large workshop and eventually dying
there. The theme of the gods' visit to the elderly
married couple is taken from Antique mythology.
This painting is the first known, independent work
by Johann Carl Loth.

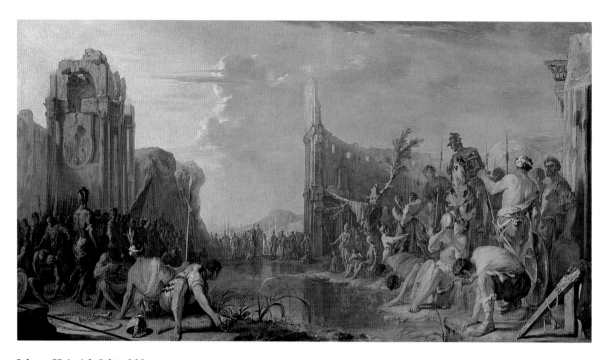

Johann Heinrich Schönfeld
Biberach/Riss 1609 - Augsburg 1683
Gideon inspecting his army, c.1640/42, signed
Canvas, 99 x 179 cm (Inv. no. 1143)
In the Prague Kunstkammer in 1663, in Vienna in 1781

The theme of the picture is taken from the Old Testament book
of Judges (7:5 ff.), recounting an episode in Gideon's war against
the Midianites: God ordered Gideon to choose for the battle only
those who 'lap(s) the water with his tongue, as a dog laps'.

Anton von Maron
Vienna 1733 - Rome 1808
Portrait of Elizabeth Hervey,
*4th Marchioness of Bristol, c.*1778/9
Canvas, 76 x 59.5 cm (Inv. no. 9796)
Acquired on the art market in 1980

With Maron, working as a portrait painter mainly in Rome
like his brother-in-law Anton Raphael Mengs, a new concept
of the portrait starts to gain ground. In his portraits he
introduces a 'sentimental' concept, appealing to the feelings
with a particularly melting look in the moist eyes and the
skin. The sitter is the wife of Frederick Hervey, Lord Bishop
of Derry and 4th Earl of Bristol, a famous or infamous
eccentric in Rome and a patron of the arts. Her pose is the
familiar attitude of contemplation, popular for intellectuals
and women in eighteenth-century English portraiture in
particular; it is also a melancholy attitude. Described by
her 'tender-hearted' husband as a 'majestic ruin', she had,
according to what she herself said in 1778, lost weight and
turned into 'a virtual skeleton like Voltaire' because of the
misery of her marriage. Whether Maron wanted to flatter
his sitter or whether she herself may have exaggerated, we
are here faced with a careworn but attractive woman in her
forties.

Anton Raphael Mengs
Aussig 1728 - Rome 1779
*St Joseph's dream, c.*1773/4
Oak, 114 x 86 cm (Inv. no. 124)
In the imperial painting gallery in 1796

The pose must have been inspired by
Michelangelo's *Jeremiah* in the Sistine
Chapel.

Spanish, French and English Painting

The small collection of Spanish painting is famous mainly for Velazquez's portraits of the infantes and infantas which will be dealt with in the chapter on court portraiture.

Antonio de Pereda's *Vanitas* refers to the ephemeral nature of all earthly power. This picture, which must have been painted about 1640, contains such clear allusions to the *Casa de Austria* (Habsburgs) that it has to be assumed it may have been a royal commission on behalf of the Spanish Habsburgs.

The art of Juan Bautista Martinez del Mazo, Velazquez's son-in-law, who succeeded him in his offices at court, evolves in the purely courtly domain. His studio picture (*The artist's family*) probably painted in 1664 transposes Velazquez's royal group portrait *Las Meninas* in the Prado in Madrid to the private domain. This produced a subtle homage to the greatest of Spanish painters, decked out with the referential wealth of the court portrait.

The wealth of French painting can be appreciated even less than can the Spanish through the few examples in the Vienna Paintings Collection.

It has not so far proved possible to establish the identity of the artist known as the Master of Heiligenkreuz who was probably active in France *c.*1400. His two-part altar (*Mystic marriage of St. Catherine*) can be characterized as a typical product of what is known as the International Style around 1400, because of the exaggerated proportions of the figures, the softly fluid style of the robes and the exquisite colouring. In the case of works of art from this period in particular it is often hard to pinpoint the place of origin, as works from Paris, Prague, Milan, Vienna or Cologne are often so similar. Until recently there was also uncertainty regarding the attribution and place of origin of the *Portrait of the Ferrara court jester Gonella*. The comment in Archduke Leopold Wilhelm's inventory was typical: 'In the manner of Albrecht Dürer from an original by Giovanni Bellini'. It was only when Jean Fouquet came into consideration as its creator that the many discrepancies fell into place.

The provenance of the pictures by Valentin and Poussin is typical of Habsburg 'collecting' of French painting in the seventeenth century. Valentin de Boulogne lived and died in Rome and continued to be a practising follower of Caravaggio until his death; hence in Leopold Wilhelm's inventory his *Moses with the Tablets of the Law* is attributed to 'Valentino', the Italian version of his name. Poussin's *Destruction of the temple of Jerusalem by Titus* is the only painting remaining in Austria by the artist

Joseph Duplessis
Carpentras/Vaucluse 1725 – Versailles 1802
Christoph Willibald von Gluck at the spinet, 1775, signed and dated
Canvas, 99.5 x 80.5 cm
(Inv. no. 1795)
In the imperial painting gallery in 1824

One of the most convincing portraits of a musician ever painted. In spite of the 'stage setting' this portrait of the great composer (1714-87) engaged in his profession is imbued with spirituality, profound emotion and inspiration.

who must be the most important Franco-Roman painter of the seventeenth century. In 1638 Poussin received the commission from the Pope's nephew, Cardinal Francesco Barberini, in Rome, and the picture was given to the imperial ambassador by the Pope in 1639 as a gift for Emperor Ferdinand III.

Regrettably there are no examples at all in the Vienna Collection of the great painting of the French eighteenth century. Christoph Willibald von Gluck, who breathed new life into musical drama, was painted by Joseph Duplessis when the Austrian composer was in Paris at the height of his career after triumphant productions of *Iphigénie en Aulide* and the French version of *Orpheus*. In this picture recording the stillness at the moment of inspiration the painter has produced a portrait epitomizing the creative artist.

The Vienna Paintings Collection provides no more than a glimpse of the wealth of moods to be found in English painting of the late eighteenth century and the range of possibilities in the reproduction of social status.

The difference between the two great poles of English painting of that period, Sir Joshua Reynolds and Thomas Gainsborough, has probably been exaggerated, playing off the man of reason, the man of letters and President of the Royal Academy Joshua Reynolds against Gainsborough, the charming Bohemian who recognized nature alone as his mentor, pursuing only the beauties of the fleeting moment, and the play of light and shadow on landscape, faces and the texture of costly clothes. Gainsborough painted the *Landscape in Suffolk* in the early 1750s while staying in his native Suffolk. The stormy movement of the clouds, the winding roads, the restless silhouettes and the sketch-like approach notwithstanding, it is a very consciously constructed landscape following the Dutch model, which may remind us that Gainsborough prepared models of his landscapes on table tops after studies from nature, assembling his compositions from coal, moss, cork, sand and asparagus plants.

Joseph Wright of Derby, inspired by an environment in which the most recent scientific discoveries and experiments were being discussed, was very keenly interested in reproducing the optical phenomena of light, dark, fire, volcanic eruptions etc. In his *Portrait of the Reverend Basil Bury Beridge* in Vienna it is primarily the cool, detached observation of humankind virtually returned by the sitter, in a sharp light that generates strong unforgettable contrasts.

Juan Bautista Martinez del Mazo
Beteta/Cuenca *c.*1612/16 -
Madrid 1667
The artist's family, *c.*1664/5
Canvas, 148 x 174.5 cm
(Inv. no. 320) Acquired 1800

Signed with the emblem of a club (*mazo* in Spanish). The four older children in dark clothes are from Mazo's first marriage with Velazquez's daughter Francisca, and on the right is Mazo's second wife Francisca de la Vega with her four children. On the pilaster in the middle ground a Velazquez portrait of Philip IV of Spain. The studio scene in the background with a portrait of Infanta Margarita Teresa and a genre scene has not been clarified.

Antonio de Pereda
Valladolid 1611 - Madrid 1678
Allegory of vanity, *c.*1640
Canvas, 139.5 x 174 cm
(Inv. no. 771)
In the imperial painting gallery in 1733

Probably painted as a commission for the Spanish court. The winged spirit holds a cameo with the portrait of Emperor Charles V in its left hand while the right hand pointing to the globe alludes to the world supremacy of the *Casa de Austria* (Habsburgs). The antique medal with the portrait of Augustus is intended to highlight the connection with the Roman Empire, or its continuity of dominion.

The Master of Heiligenkreuz
Fl. in France
c.1395 - *c*.1420
*Preaching and Mystic marriage of St Catherine, c.*1410
Panel, 72 x 43.5 cm
(Inv. nos 6523, 6524)
Acquired from Heiligenkreuz monastery in Lower Austria in 1926

Jean Fouquet
Tours *c*.1415/20 - Tours 1481
Portrait of the Ferrara court jester Gonella,
*c.*1440/45
Panel, 36 x 24 cm (Inv. no. 1840)
Archduke Leopold Wilhelm
collection 1659

The attributions mentioned in Leopold Wilhelm's inventory – Dürer, Giovanni Bellini – were to be followed by others: van Eyck, mid-fifteenth-century Netherlandish in general, Pieter Bruegel the Elder. As well as stylistic comparisons with authenticated works by Fouquet, the attribution to a French artist is supported by the results of infra-red reflectography: in the drawings underlying the painting, colour instructions written in French showed up.

Valentin de Boulogne
Coulommiers 1591 - Rome 1632
Moses with the Tablets of the Law, *c*.1630
Canvas, 131 x 103.5 cm (Inv. no. 163)
Collection of Nicolas Régnier, Venice;
Archduke Leopold Wilhelm collection 1659

Nicolas Poussin
Les Andelys 1594 - Rome 1665
*Destruction of the temple of Jerusalem by
Titus*, 1638, signed
Canvas, 148 x 199 cm (Inv. no. 1556)
Commissioned by Cardinal Francesco
Barberini and given to the imperial envoy
Prince Eggenberg in Rome as a gift for
Emperor Ferdinand III. In the imperial
gallery in Prague before 1685. In the
Stallburg in Vienna in 1720. Bought back
from Prince Kaunitz in 1820

Thomas Gainsborough
Sudbury 1727 - London 1788
Suffolk landscape, c.1750
Canvas, 66 x 95 cm (Inv. no. 6271)
Humphrey Roberts auction 1908
Acquired from Agnew's in 1913

Joseph Wright, known as **Wright of Derby**
Derby 1734 - Derby 1797
Portrait of the Reverend Basil Bury Beridge, c.1780/90, signed
Canvas, 127 x 101 cm (Inv. no. 6237)
Rev. B. Beridge auction, Christie's, London, 1911. Gift 1912

After a journey to Italy which left its mark and two years in London, Wright of Derby returned to his native town where he painted primarily the men behind the incipient industrialization of northern England. The coolness and rationality of this society may also be discernible in this portrait of the rector of Algakirk (Lincolnshire).

Court Portraiture

The many aspects and goals of the court portrait make it inevitable that the highest artistic claims could not always be met. It is primarily the double nature of the task that inhibits a free deployment of painterly skills: 'Copying what can be seen, observing the character and the psychological impulses on the one hand, and on the other documenting the paramount principles of acting and behaving correctly in the historic play of forces ... ultimately of the correct ordering of the state' (Heinz). A balance had to be achieved between conventional portrait formulae expressing abstract principles and a penetrating interpretation of the character of the individual.

The artistic worth of the portrait and its formal or official function as an instrument of propaganda are often independent of one another. The court portrait did not develop until the reign of Emperor Maximilian I and was guided by his ideology. Dürer's famous portrait of *Maximilian I*, the 'last knight', made a permanent impression on posterity's image of him as a ruler. A glance at Holbein's portrait of the English queen *Jane Seymour* painted in 1536 gives some idea of the wide range of possible approaches at the highest artistic level. In the work of Bernhard Strigel, Maximilian's court painter who came from Swabia, and of Cranach and his disciples the emphasis tends to be on the supra-individual. This always implies a latent danger of, to some degree, draining the portrait of expression.

'German' painting played a crucial role in determining the aspect of the full-length portrait too, a type which was capable of conveying greatness and princely virtue to a large extent without resorting to any external symbols or insignia. Jacob Seisenegger's portrait of *Charles V with his Ulm mastiff* painted in Bologna in 1532 was the direct model for Titian's 'copy' in the Prado in Madrid, and hence a typological point of departure for many other artists. Another important court painter was Anthonis Mor, who worked primarily for the Spanish Habsburgs in Brussels and Madrid and must be regarded as 'one of the creators of the ideal political figure' (Heinz). He combined the sharp observation of the tangible material peculiar to Netherlandish painting, of physiognomical detail, with an arrangement of the pictural elements which could impart directly to the viewer the expressive qualities of the severe, the unapproachable, of something pointing beyond the individual. The attitude, gestural behaviour and accessories of the type represented in his full-length portraits would then be carried on in Spain and ossified in a way that has a peculiarly intense impact in the work of Sanchez Coello and other Spanish court painters, down to Velazquez and his followers.

Diego Velazquez
Seville 1599 - Madrid 1660
Infanta Margarita Teresa in a blue dress, 1659
Canvas, 127 x 107 cm
(Inv. no. 2130)
Sent to the court in Vienna as a gift in 1659

After the *Casa de Austria* had split into a Spanish and an Austrian line, very close dynastic links existed between Vienna and Madrid which the Habsburgs sought to strengthen by means of marriage. It is due to their desire to see the prospective candidate that the Vienna Paintings Collection has a magnificent series of portraits of infantes and infantas by Diego Velazquez, court painter in Madrid, which mark the summit of court portrait painting. Margarita Teresa, the first child born of King Philip IV of Spain's second marriage with his direct niece Maria Anna, a daughter of Emperor Ferdinand III (who was therefore both cousin and mother to the infanta), was born in 1651. At an early age she was betrothed to her uncle and cousin, subsequently Emperor Leopold I, eventually marrying him in 1666.

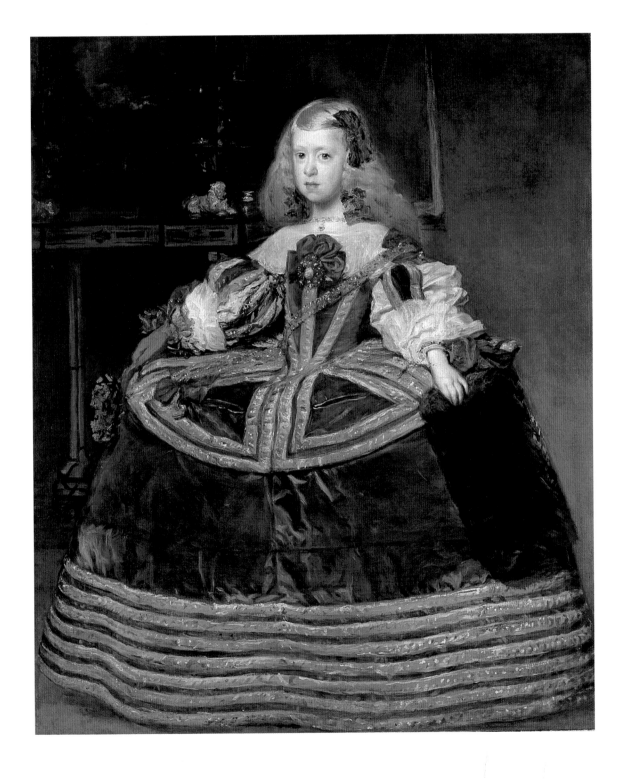

Mor, Seisenegger, Cranach and Titian met at the Imperial Diets held in Augsburg in 1548 and 1550. The concept of the court portrait is stamped through and through by the Habsburgs, and spread from this area right across Europe. Titian's portrait of *Elector John Frederick of Saxony* in Vienna was painted at that time, no doubt commissioned by the emperor himself. Although Titian's portrait art is unsurpassed at expressing distinction and moral greatness, it is so individual that it had very little influence on the immediately subsequent development of the court portrait and did not bear fruit until the time of Rubens and Van Dyck, when new life was breathed into the rigid portrait formulae of the late sixteenth century.

Rubens is represented here by copies after portraits by Titian and historicist court portraits after early Netherlandish models. While the 'instrumentation' in Van Dyck's portrait of *Prince Rupert of the Palatinate* has all the trappings of the traditional court portrait, the painter is extremely ingenious in seeming to involve him (Rupert) in action. The result is a characteristic image of effortlessly haughty elegance and command, the prototype for aristocratic portrait art up until the twentieth century.

The Vienna Paintings Collection is especially renowned because of Velazquez's portraits of the infantes and infantas. As court painter to Philip IV, Velazquez adheres to the traditional gestures and trappings of the official portrait. However he dissolves everything tangible into undiluted, purely optically effective painting. The perfect equilibrium between the task of producing an official portrait, penetration into the individual and a painterly work of art is even more discernible here than in the work of Van Dyck, being achieved without nervous affectation.

Nothing comparable could be set against this on the side of the Austrian Habsburgs. They remained conservative and also largely uninfluenced by the new style of portrait developed at the court of Louis XIV, which must be represented in its purest form by Hyacinthe Rigaud. It is mainly distinguished by the ostentatious display of symbols of state and power, but also by the parade of the person, enlarged to a mighty presence by means of turbulent drapes. Moreover, it soon became very clear that this 'bombastic' official display of the ruler could no longer be convincing in a period of tumultuous change, especially as from the second half of the eighteenth century an 'enlightened' portrait type was prized in courtly circles, in which a claim to moral superiority was associated among the Habsburgs in particular with a marked tendency to emphasize family and bourgeois characteristics.

Bernhard Strigel
Memmingen *c.*1460 - Memmingen 1528
Emperor Maximilian I and his family, 1516
Panel, 72.8 x 60.4 cm (Inv. no. 832)
Painted for Emperor Maximilian, then owned by
the humanist Johannes Cuspinian, an adviser to
Maximilian I; recorded in the imperial collections
in Vienna *c.*1615

The picture refers to the double betrothal in
Vienna in 1515 determining the connection
of the Habsburgs with the Jagello family, the
royal house of Hungary. Cuspinian had Strigel's
panel painting extended into a complete 'Holy
Family' by adding a reverse side and a second
panel. What is clearly predominant here is the
political and dynastic function of the court
portrait which is discernible in a reduction in
individual characterization.

Albrecht Dürer
Nuremberg 1471 - Nuremberg 1528
Emperor Maximilian I, 1519,
monogrammed and dated
Wood, 74 x 61.5 cm (Inv. no. 825)
Not definitely recorded in the imperial
gallery until 1781

As a deliberate promoter of the arts
Maximilian (1459 - 1519) was quite
clear in his own mind about their
importance in legitimizing his policy
and for his own posthumous fame.
Dürer's drawing (Vienna, Graphische
Sammlung Albertina) from life was
made in Augsburg in 1518. The portrait
itself was not completed until after the
emperor's death. Depicted not as the
emperor but as a 'private man', in his
left hand Maximilian is holding a
pomegranate, a symbol of power, wealth
and unity, rather than the imperial orb.

Jacob Seisenegger
Lower Austria 1505 - Linz 1567
Emperor Charles V with his Ulm mastiff, 1532,
monogrammed and dated
Canvas, 203.5 x 123 cm (Inv. no. A 114)
Recorded in the imperial collections in Prague
in 1685

Emperor Charles V (1500-58) became king
of Spain as Charles I in 1516, and Holy Roman
Emperor in 1519, and was crowned in Bologna
in 1530; he abdicated and retired to the San
Yuste monastery in 1556. He was a politician
with worldwide influence and a patron of the
arts. This portrait, commissioned by the man
who later became Emperor Ferdinand I, is one
of the points of departure for the development
of the full-length court portrait.

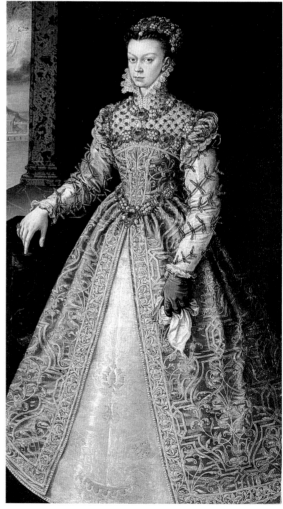

Alonso Sanchez Coello
Alqueria Blanca/Valencia 1531/2 - Madrid 1588
Isabella of Valois, Queen of Spain, c.1560
Canvas, 163 x 91.5 cm (Inv. no. 3182)

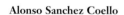

Isabella of Valois, born in 1546 as the daughter of Henry
II of France and Catherine of Medici, married King Philip
II as his third wife in 1559; she died in 1568. She was the
mother of Infanta Isabella Clara Eugenia. On the pearl cap
there is a monogram formed from a 'Y' and an 'F' (for
Ysabella and Francia).

Anthonis Mor
Utrecht *c*.1517/20 - Antwerp 1576/7
Antoine Perrenot de Granvelle, 1549,
signed and dated
Panel, 107 x 82 cm (Inv. no. 1035)
In the imperial gallery in 1772

Granvelle (1517 - 86) who came from
Burgundy was the son of Nicolas, the
powerful secretary of state of Charles
V, and his successor from 1550. He
became Bishop of Arras at the age of
21, Archbishop of Mechelen, and in
1561 a cardinal, and was a powerful
and detested president of the Secret
Cabinet Council of the Netherlands
under Margaret of Parma; dismissed
in 1564; Spanish ambassador in Rome,
and Spanish viceroy in Naples 1571
to 1575.

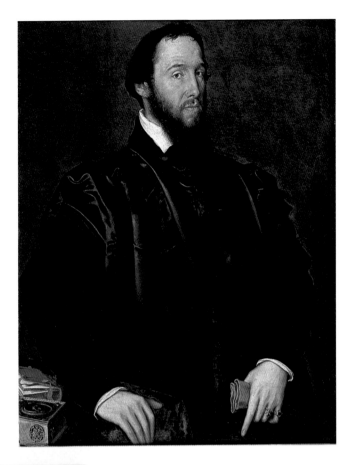

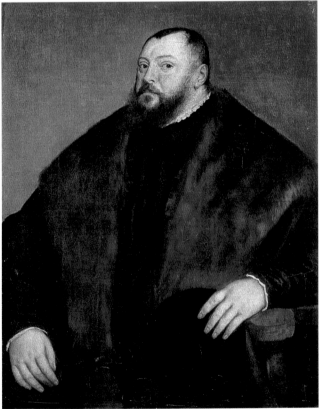

Titian, properly **Tiziano Vecellio**
Pieve di Cadore *c*.1488/90 - Venice 1576
Elector John Frederick of Saxony, 1550/51
Canvas, 103.5 x 83 cm (Inv. no. 100)
Acquired by Archduke Leopold Wilhelm

John Frederick the Magnanimous (1503 - 54),
the emperor's adversary in the Schmalkaldic War,
was taken prisoner by Charles V at the Battle of
Mühlberg in 1547 and Titian painted his portrait
during his imprisonment in Augsburg. In a brilliant
move Titian barely fits his model into the picture
area in order to characterize the monstrously fat
elector in all his unapproachable dignity and the
darkly brooding repose of a man whose freedom
of movement was restricted.

Anthony Van Dyck
Antwerp 1599 -
London 1641
*Prince Rupert of the
Palatinate, c.*1631/2
Canvas, 175 x 95.5 cm
(Inv. no. 484)
In the imperial collections
in Vienna in 1730

Rupert (1619-82) was
the younger son of the
Protestant Elector of
the Palatinate and later
King of Bohemia, the
'Winter King' Frederick
V, and the sister of King
Charles I of England.
The traditional
instrumentation of the
full-length court portrait,
through Van Dyck's
ability to transform
accessories of status,
costume and pose into a
psychologically motivated
'internal' action, produced
this picture that even now
influences our concept of
aristocracy.

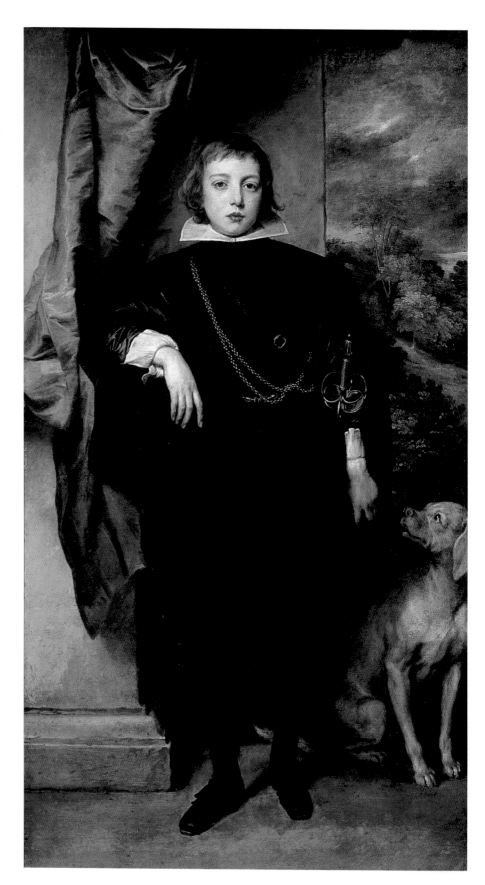

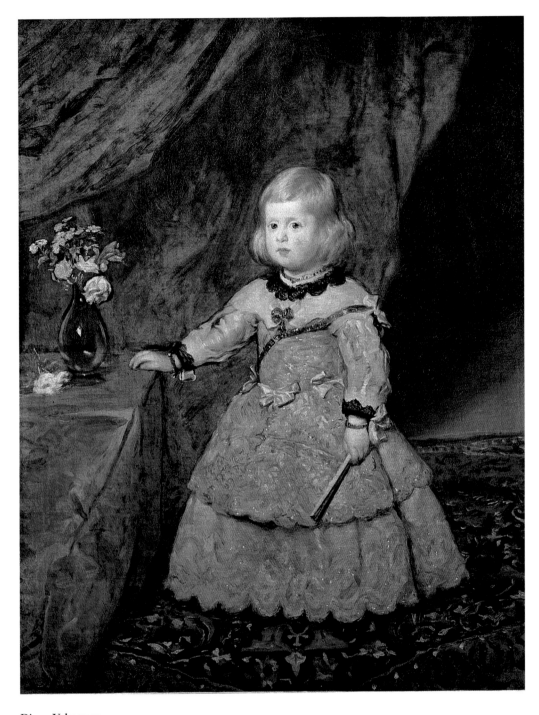

Diego Velazquez
Seville 1599 - Madrid 1660
Infanta Margarita Teresa in a pink dress, c.1653/4
Canvas, 128.5 x 100 cm (Inv. no. 321)

The first of the three portraits of the infanta born in 1651 held in the Paintings Collection. Velazquez uses the traditional accessories of the Spanish court portrait for a girl of about three. With incredible deftness Velazquez incorporates what is seen into a structure – only seemingly loose – of freely applied unmerged brushstrokes and touches of colour in which nothing can be shifted or exchanged. The web of brushstrokes combines into coherent corporeality only when viewed from a certain distance.

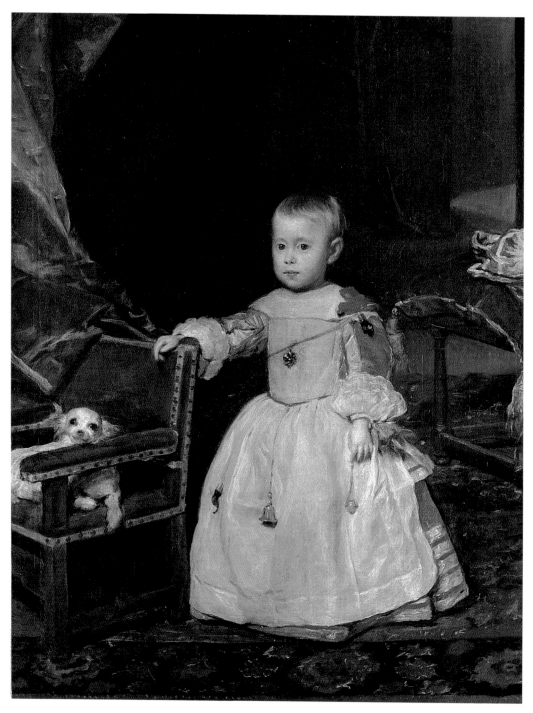

Diego Velazquez
Seville 1599 - Madrid 1660
Infante Felipe Prospero, 1659
Canvas, 128.5 x 99.5 cm (Inv. no. 319)
Sent as a gift to the court in Vienna in 1659

The sickly-looking infante (1657-61) – it is not for nothing that he is wearing the little bell over his white
overall and coral amulets to ward off ill-fortune – in whom all hopes of an heir to the throne had been
vested died just two yeas after Velazquez's portrait. The hunting dog which often appears in the court
portrait, a reference to the faithful, obedient subject, is replaced by a big-eyed lap dog. By the reduced scale
of the accessories alone Velazquez characterizes the prince's fragile hold on life.

126

Hyacinthe Rigaud
Perpignan 1659 - Paris 1743
Count Philipp Ludwig Wenzel of Sinzendorf, 1728
Canvas, 166 x 132 cm (Inv. no. 9010)
Gift of Clarisse de Rothschild 1948

The diplomat (1671-1742), shown wearing the insignia of the Golden Fleece, took part in the negotiations at the Soissons Peace Conference in 1728. He was a high-ranking official under three emperors, Leopold I, Joseph I and Charles VI. A rare example in the Austrian field of the French portrait type found in the reign of Louis XIV and his immediate successors.

Pompeo Batoni
Lucca 1708 - Rome 1787
Emperor Joseph II and Grand Duke Pietro Leopoldo of Tuscany, 1769, signed and dated, in the original frame
Canvas, 173 x 122 cm (Inv. no. 1628)
Recorded in the imperial painting gallery in 1824

This 'friendship portrait' of the two princes, Emperor Joseph II (1741-90, emperor from 1765) and his younger brother Pietro Leopoldo (1747-92, Grand Duke of Tuscany 1765, from 1790 emperor as Leopold II), was painted during a meeting between the two men in Rome. Batoni dispenses with all pomp and presents the young rulers as travellers on their Grand Tour; reference is made to the maxims of the Enlightenment by means of Montesquieu's *L'esprit des lois*.

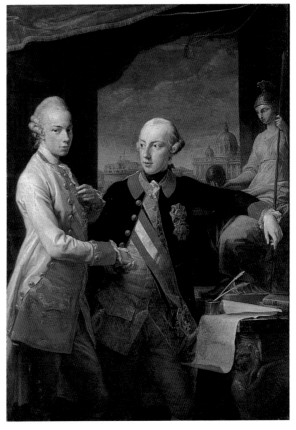

Bibliography

AAVV, *Kunsthistorisches Museum Wien, Führer durch die Sammlungen*, 3rd edition, Vienna 1996

Ferino-Pagden, Sylvia; Prohaska, Wolfgang; Schütz, Karl: *Die Gemäldegalerie des Kunsthistorischen Museums in Wien. Verzeichnis der Gemälde*, Vienna 1991

Haupt, Herbert: *Das Kunsthistorische Museum. Die Geschichte des Hauses am Ring. Hundert Jahre im Spiegel historischer Ereignisse*, Vienna 1991

Kriller, Beatrix; Kugler, Georg: *Das Kunsthistorische Museum. Die Architektur und Ausstattung. Idee und Wirklichkeit des Gesamtkunstwerks*, Vienna 1991

Lhotsky, Alphons: *Geschichte der Sammlungen*, 2 vols., Vienna 1941, 1945

Meijers, Debora J.: *Kunst als Natur. Die Habsburger Gemäldegalerie in Wien um 1780*, Vienna 1991

Index